MYLES BIRKET FOSTER, RWS
1825 – 1899

MYLES BIRKET
FOSTER
1825-1899

by

FRANK LEWIS

F. LEWIS, PUBLISHERS, LTD
PUBLISHERS BY APPOINTMENT TO THE LATE QUEEN MARY
The Tithe House, Leigh-on-Sea, England

PRINTED AND MADE IN ENGLAND

©
COPYRIGHT BY
F. LEWIS, PUBLISHERS, LIMITED
The Tithe House, Leigh-on-Sea
England
SBN 85317 022 3

First Published 1973

Published by F. Lewis, Publishers, Ltd.
and printed at the Daedalus Press, Stoke Ferry

TABLE OF CONTENTS

Background and Early Days

THE subject of this monograph was a man of many parts. During his life-time he applied himself seriously to more than one branch of the creative arts and never lost an opportunity of exploiting his skills to the fullest extent.

Although he became well-known as an illustrator of books and magazines he was also an informed and informing traveller as a result of the commissions he received and which sent him, during middle life, to many parts of Europe. Considering the vast number of drawings and paintings he managed to produce it is surprising to find in him the makings of a bibliophile and an enthusiastic collector not only of books but also paintings, drawings and china. Towards the end of his life he became interested in amateur dramatics, an interest which evolved from the regular contacts he maintained with his friends. It is said that one learns a great deal about a man by the friends he possesses and in this respect Birket Foster comes out very well having known some of the most interesting and distinguished people of the nineteenth century, many of them artists like himself but all of them without exception warmly disposed towards him.

It is rather extraordinary that a man with so many interests and ambitions to excel should fail so conspicuously to win wholehearted acclaim from the critics. To say that he was a 'Jack of all Trades . . . ' would be unfair: what, then, was the reason for his limited success? How is it that he will never be described as a 'great' painter of water colour? The answer may be found in the pages which follow, but first, let us look into the background of his early beginnings and the people who influenced his progress in the career of his choice.

Born at North Shields on February 4th 1825 he was not without a long ancestry for in a volume entitled 'The Pedigree of the Forsters of Cold Hesledon in the County Palatinate of Durham', the family tree shows that the Fosters, all of whom held good social positions, could be traced back to the seventeenth century and that they were for many generations brought up in the Quaker tradition. One, Sarah Forster, (this spelling of the surname seems to have been its early form), married a descendant of Margaret Fell, of Swarthmore Hall who, after the death of her first husband, Judge Fell, was united to George Fox, founder of the Quakers.

Birket Foster, as he is generally known, or Myles Birket Foster to give him his full name, was the youngest but one of seven children – six boys and a girl – and his father, Myles Birket Foster, married Ann King, a member of a Newcastle Quaker family, on the 11th April 1811.

The boy's grandfather was a character quite unlike the rest of the family and must have been a source of disappointment, if not distress, to his relations on account of his abandoning principles which they embraced so strongly. A naval officer of some repute

he was in action several times yet was still possessed of some scholarly distinction outside his professional occupations, that is if one is to believe Robert Southey who wrote in 1806, '. . . He was scholar enough to quote Vergil aptly . . . his head was well stored and his heart in the right place.'

Robert Foster, for that was his name, married Mary Burton in 1784 and his eldest son, born at Hebblethwaite Hall, in the County of York, was named Myles Birket Foster after his maternal grandfather who was still alive at the time. As already stated this eldest son was our artist's father.

The Foster family moved from North Shields to London in 1830 travelling, it is said, all the way by sea. They took up residence at 40 Charlotte Street Portland Place and Birket Foster, then five years old, was sent to a dame school run by two worthy spinsters at Tottenham. There was a tradition in the family that the boy could draw before he could speak and that the local renown of the great Thomas Bewick, who was alive when Birket was born and was then at the height of his fame, influenced the budding young artist who was destined to achieve distinction on his own account. He, himself was, however, less certain about the origin of his earliest efforts preferring to attribute his infant skill to the patient tuition given by his teachers at the Tottenham school and, later, at a school for Quaker children at Hitchin, in Hertfordshire where he stayed until 1840. Perhaps it should be mentioned that the rudiments of his tuition included lessons in pencil drawing by a competent artist, Charles Parry, who was well-known in the early forties in London.

In due course the time arrived when it became necessary to consider what should be done with the boy whose own particular inclinations lay in the way of an artistic career, especially that branch of it which had to do with landscape, despite the fact that at the time there was little promise in such a choice.

The Foster family enjoyed the acquaintance of a number of notable artists and eventually a sort of compromise was agreed upon which led to the approach to a Mr Stone, a die-engraver, to whom it was arranged that the boy should be apprenticed. However, on the very day that the articles were to be signed the poor man, for some reason unknown, committed suicide and the tragedy naturally put an end to the project and caused the family to think again. This time another friend of the family was consulted resulting in the youth being taken into the office of Ebenezer Landells, a Newcastle on Tyne man who had established himself as a wood engraver and who had been a pupil of Thomas Bewick. Here Birket Foster worked from 1841 to 1846.

At first he was given the task of cutting the wood block, (which process about this time was regaining its popularity at the expense of the older and now demode method of steel engraving), but this was not persisted in when Landells discovered that his pupil's abilities lay in drawing and thereupon encouraged him to work as a draughtsman, a course which resulted in many hundreds of blocks being drawn by his hand during the years that followed.

The wood engravers at this period were mainly employed in contributing to such

publications as the *Penny Magazine* and the numerous publications of Charles Knight: and there was also an opportunity for them to work on illustrations for *Punch* and the *Illustrated London News*. Birket Foster was early on the scene in connection with both these periodicals and from the 5th September 1841 (when his first slight effort was printed in *Punch,* his work appeared with some regularity, first in the shape of decorative initials, (always in demand by this publication), and later small caricatures etc. It was in Landells office that our industrious young artist first met John Greenaway, the father of Kate Greenaway, and Edmund Evans, later to become a skilful colour printer. Between the two a close friendship sprang up which existed without interruption during the remainder of their lives.

The *Illustrated London News,* which first appeared in 1842, was suggested by the large sales obtained by the *Weekly Chronicle,* a lurid 'rag' concerned wih describing in colourful detail the latest crime of the day. The illustrations of the former were built up from various sources, one of the earliest, that of the great Hamburg fire in 1842, was actually produced by simply altering an old block of the City. Later on, as the proprietors were able to improve on this situation, Birket Foster was often sent out to different locations to depict incidents which happened to be of interest. When Queen Victoria, in 1845, went to Germany Landells himself went as a special artist to illustrate her progress and the sketches, as they were sent home, were drawn on the block by Foster. (N.B. One of Birket Foster's original drawings for the *ILN* is shown on page 2 of the Art Journal monograph and there are also one or two line drawings in Pennell's book *Modern Illustration* 1895).

During his employment with Landells Birket Foster spent his spare time in the countryside making studies of trees and shrubs in water colour. Also he received much kindness from Jacob Bell, the collector of Landseer's works, who gave him generous encouragement in many ways. Jacob Bell was a friend of the Fosters and no doubt because of the young man's interest in Landseer he lent him a number of that artist's proofs which were then being engraved. One day, presenting a pen and ink drawing after one of these studies to Mr Bell the latter was so pleased with it that he suggested it should be shown to Landseer but Birket Foster was shy about the idea and would not go thus missing an interview that might have been of inestimable value to him. However the incident was not without its compensation for the drawing was later sold for 20 guineas, the first considerable sum he had received in this way.

Landells was a great benefactor towards his worthy pupil and employee for during the whole of the time the latter worked for him he watched over him with a solicitously parental eye. After an illness, caused by a coach accident, Landells gave him leave of absence with these words of advice: 'Now that work is slack in the summer months, spend them in the fields; take your colours and copy every detail as carefully as you can, especially trees and foreground plants, and come to me once a month and show me what you have done'. Foster took himself off and did as he was told with the result that his drawings were executed with the greatest accuracy of natural detail.

It was during his years with Landells that a book of poems on Richmond, in Surrey, was produced with three illustrations drawn by him.

B IRKET FOSTER began his long connection with the *Illustrated London News* by reason of his joining forces with his friend Edmund Evans in a small wood engraving business. This was in 1848 by which time he had been parted from Ebenezer Landells nearly two years.* Most of the work consisted of cutting blocks for this magazine and, of course, Foster's flair for drawing constituted an invaluable contribution to the success of the venture. Hesketh Hubbard, in his book, (see note below), states that one of the earliest commissions the firm received was to cut Birket Foster's illustrations to *Travels in the Holy Land.* 'It was', he writes, 'practically the same process as George Baxter used for the production of his Baxter prints . . . Birket Foster would draw the outlines on a block which Evans cut and from which he pulled a proof. This Foster coloured and from the coloured proof Evans cut the two colour blocks'.

There seems to be no reason to doubt this statement although the book is not mentioned in Cundall's *List of Principal Books Illustrated by Foster* until the year 1853 is reached. However it is pretty clear that our artist was working on drawings for the *Illustrated London News* while still at Landell's office. Cundall asserts that he was employed by Landells to make several drawings for the magazine the first of which appeared in July 1846, the year when he left Landells and, for the first time, found himself left to his own resources.

In search of work he called on several firms with a selection of drawings, most of them being drawn on the wood, but met with little success until he met Henry Vizetelly then in a thriving business as a publisher and was at once commissioned to illustrate a book Thomas Miller had written for Chapman and Hall entitled, *The Boy's Spring and Summer Book* (N.B. an illustration is given on page 4 of the Art Journal monograph). This was followed in 1850 by *Evangeline,* a poem by Longfellow about which the *Athenaeum* wrote, 'A more lovely book than this has rarely been given to the public. Mr Foster's designs in particular have a picturesque grace and elegance which recall the pleasure we experienced on our first examination of Mr Roger's *Italy* when it came before us illustrated by persons of no less refinement and invention than Stothard and Turner'.

Evangeline had an enormous success and in view of the satisfactory sales no time was lost in advertising further 'uniform volumes' to come, all of which, as it turned out, were to be illustrated by Birket Foster. Marriage to his cousin, Ann Spence, was to come on the 13th August 1850 so that this year must have been an especially important

* An interesting reference to the progress of Edmund Evan's business occurs in Hesketh Hubbard's book, *Some Victorian Draughtsmen* 1944.

one for him. This marriage lasted only nine years his wife dying in 1859. Longfellow's *Hyperion* published in 1853 called for a trip to the Austrian Tyrol with Henry Vizetelly in order to obtain accuracy of location and the visit, the first of many subsequent journeys abroad, was a valuable experience for the young man. Some of the drawings for the *Illustrated London News* may be mentioned in particular the one he did to commemorate Queen Victoria's visit to Portsmouth in 1848 to open the new Steam Basin there. Two wood-cuts appeared from his drawings, 'The Mayor of Portsmouth presenting an Address to the Queen' and ' "The Fairy" entering the new Basin' (N.B. A reproduction of the former drawing is to be found in Cundall, page 38).

There were many other newsworthy drawings and in 1849 he was commissioned by the magazine to visit different watering places in England as a result of which views of such places as Worthing, Hastings, Bridlington and Dover appeared with some regularity. On these trips he was usually accompanied by his friend Edmund Evans who, in fact, engraved most of Foster's work. As may be imagined both men enjoyed these excursions greatly for there was much to be seen and also to be learnt from them.

The most characteristic works of Birket Foster were the delightful engravings executed in the Supplements and Christmas numbers of the *Illustrated London News*. The latter were without rivals during the middle of the last century and most of the popular artists of the day were commissioned to make drawings for them, e.g. John Gilbert, John Leech, K Meadows and others drew the jovial scenes and it was generally reserved to Birket Foster to supply those scenes which appealed to the poetic feelings of the festive season.

It was in 1855 that the magazine published the first of its coloured engravings and the following Christmas a coloured plate by Foster entitled, 'Winter'. This was followed in 1857 by a large double-page illustration by him entitled, 'The Happy Homes in England'. 'Christmas – the cottage door' appeared in 1859 and was probably about the last of his drawings for this celebrated magazine – the date also nearing the ending of his book illustrating work. The trip up the Rhine with Vizetelly made a great impression and his sketches were incorporated in two books dealing with the localities visited viz. *The Rhine* and *The Upper Rhine* the first one being written by Henry Mayhew, one of the founders and first editor of *Punch*. *The Rhine* came out in 1855, the other book shortly after.

Many commissions for book illustrations (there is a full list in Cundall) were carried out during the years which followed including many of Walter Scott's poems and Foster made several visits to the scenes mentioned by the poet including both Scotland and Wales which also provided material for a series of guide books published by Black of Edinburgh.

From this time on the entirety of the illustrations for almost every book he was engaged upon were placed in his hands: he selected his own subjects and commissioned, where necessary, other artists to add their work to his own. The publishers, seeing in him such an experienced and dependable illustrator ransacked their shelves

for subjects suitable to be dealt with by him among which was Martin Tupper's celebrated *Proverbial Philosophy* (a favourite book of Queen Victoria's), the 1854 edition of which contained drawings by Foster.

At this period the number of artists engaged upon book illustration who eventually became eminent was quite remarkable: no similar period seems to have borne any resemblance to it in this respect. Of painters there were Leighton, Millais, Burne Jones, Rosetti and Holman Hunt: of water colourists, J Gilbert, G Dodgson, E Duncan and Hine: while among black and white artists the name of John Tenniel stands out most prominently.

Checking on the list of works illustrated by Birket Foster reveals the fact that at least three quarters of them consist of poetry, but although a number of the foremost poets of the day are represented it is noticeable that he never illustrated Tennyson,* Shelley or Keats. The reasons for these omissions must be a matter of surmise: it is believed that Foster, under instructions from the publisher he was then working for actually started work on Tennyson's poems when differences arose and Tennyson declined to allow work to proceed.

Most artists will agree that at least a fair proportion of their work fails to come up to expectation and as a consequence is either put on one side or destroyed. Birket Foster cannot have been an exception and must have counted many failures among his prolific output. As will be seen in a following chapter he contributed over five hundred paintings during his membership of the Royal Society of Painters in Watercolours between 1862 and 1899 a remarkable achievement in view of the painstaking detail insisted upon in all his works.

Birket Foster's labours in book illustration practically ended after 1860: † it is, however, of interest to note that in 1878 he used a lithographic process for some drawings he had made the year before in Brittany. About thirty sketches in all these included scenes of rural life in such places as Vitré, Quimper, Morlaux, Dinan and St Malo and the book was published privately. The same process was also used in connection with the reproduction of some vignettes designed ten years later, of the principal towns of England.

* On at least one occasion Birket Foster visited the Tennyson home at Farringford, I.O.W.

† See Appendix 3 for list of Books illustrated 1841-1873.

The Colourist

IT SEEMS that Birket Foster, even when fully engaged in making drawings for reproduction in books and magazines, never ceased dreaming about painting and to this end spent a good deal of time and money practising the art of water colour and oil painting. Many of his experimental drawings and canvases as has already been mentioned, were thrown away and it is on record that he and his friend, Edmund Evans, once dropped a large bundle of discarded work in the Thames at dead of night, but disillusion besets all artists at some time or another and success usually attends he who recognises the fact as a passing phase.

About the time Birket Foster launched himself seriously on his painting career the school of landscape painting was not such as to command respect: there was Turner, of course, for whom Foster had great admiration but at this period, (the end of the 1850's), Turner's life was drawing to a close and only flashes of his former genius could be expected.

Other painters there were who provided some impetus to his aspirations, Collins, Creswick, Martin, Dancy and Copley Fielding, but Clarkson Stanfield probably in-fluuenced him more than anyone especially in regard to his mastery of composition. His massive foregrounds were studied carefully as well as the delicate distances which gained so notably from this painter's habit of bringing in a block of timber or a felled elm trunk for this purpose. Ruskin, too, was issuing the volumes of *Modern Painters* and may have encouraged his special enthusiasm for the basic truths of nature.

Be that as it may in 1859 Birket Foster sent in some of his work to the Old Water Colour Society in support of an application for membership and the examples he sub-mitted were, to his great disappointment, rejected. He did, however, gain some conso-lation from the fact that a water colour painting sent to the Royal Academy, in that year, was accepted and hung. He called it 'A Farm near Arundel'.

The year 1860 saw his election as an Associate of the Water Colour Society on the strength of four paintings shown in the Catalogue as No. 30 'Feeding the Ducks', No. 208 'View in Holmwood Common', No. 236 'Children going to School' and No. 276 'View on the River Mole'. This exhibition, the 56th by the way, was open from Nine o'clock to Dusk. The Admittance fee was one shilling and Catalogue six pence.

Queen Victoria made a habit of visiting these exhibitions during the life-time of the Prince Consort and Birket Foster had the honour of being asked whether he would sell one of his paintings to her. Unfortunately the picture selected was already sold – it is not known or revealed how he managed to get round the difficulty.

Foster's elevation to the rank of full Member of the Society followed within two years of his admission as Associate and in 1863, as will be seen from the List referred to above he exhibited no fewer than nine paintings on that occasion. He was now at

the height of his powers and although he must have busied himself in all sorts of other activities he always sent in a goodly number to the Society's main exhibitions. (See Appendix I).

He was, at this time, living at Carlton Hill, St John's Wood but soon found that the urban life produced too many distractions for a serious and dedicated artist. The death of his father in 1861, may have been partly responsible for his disenchantment with life in the great Metropolis for the Society's 1863 Catalogue gives his address as Witley, Surrey,* which was, in fact, a cottage at Tigburn at the foot of the hill upon which he was to make his permanent home.

In 1866 he made his first visit to Venice and two years later repeated the experience this time with a party which later included Fred Walker who was travelling independently and met them accidentally. It was evidently a jolly encounter for Walker, subsequently to become A.R.A. appears to have been up to all kinds of mischief and even invented, so it is said, a form of 'Gondola combat' which consisted of splashing one another until one side or the other became too wet to continue the struggle. Birket Foster made at least seven more visits to Italy, one of them at least being very profitable in the way of commissions but he always maintained that none was as enjoyable as the one he undertook with Fred Walker in his party.

It is evident that Foster never felt the same satisfaction from oil painting as he did from his use of the water colour medium. It is true that his name is found continuously in the Academy catalogues between 1869 and 1877, during which time he showed fourteen oil paintings, (the first picture accepted in 1859 was a water colour), but in spite of this gratifying situation he seems to have realised that practising both oil and water colour was incompatible with real progress in either and, as a consequence, he virtually discontinued the method of painting after 1877. It should be mentioned that in 1876 he was elected a Member of the Royal Academy of Berlin, but long before this, in 1869 in fact, he had made a very extensive tour of Belgium, Holland and the Rhine in connection with drawings he had been commissioned to do for an illustrated edition of Hood's poems. On this trip he took with him his son, Myles, and Alfred Cooper, son of Abraham Cooper R.A. Ostend was the first town to be visited, because Hood had lived there from 1837 to the Spring of 1840, and from Ostend the party travelled to Bruges, Ghent and Antwerp, thence to Rotterdam, the Hague and up the Rhine to Coblenz.

As a result of his sketching tours of the Continent during the late 70's Birket Foster, as stated in Chapter II, was able to publish on his own account a book of thirty five 'drawings' which he had executed in different parts of Brittany. In the Preface to this book he referred to the lithographic process which he had adopted in the reproduction

* 'Before Hindhead drew authors and artists up the hill Witley had its own settlement of workers living deep in Surrey country. George Eliot was at Witley Heights; J C Hook, who could not bear to be watched while painting, sketched Witley gorse and heather. Birket Foster long lived among the Witley pines'. *Highways & Byways in Surrey,* Eric Parker. Illustrations by Hugh Thomson. 1908.

of the drawings and claimed that transferring them to the stone was so perfect that the pictures might be said to have been printed from the actual drawings.

Cundall, in his book on Foster comments interestingly on the artist's method of working in water colour. Birket Foster, he writes, worked with his brush as dry as it could be and probably no artist in using this medium ever employed so little water. It was like drawing with a brush, Cundall says, 'He used a very fine brush with very little paint in it, and owing to his habit of frequently putting it to his lips to make the point of it as fine as possible it used to be said that the paint came out of the artist's head.'

He used thick board to work on and thus escaped the necessity of straining paper, and once embarked on his task, worked very rapidly, composing the scene with remarkable speed and felicity. Apparently he rarely used a model his children, for instance, being drawn directly from the country boys and girls whom he found in the course of his travels.

Many of Birket Foster's paintings and drawings done during middle life were bought straight from his studio and dealers often sought him out while he was in Surrey anxious to acquire his work. His paintings at the Water Colour Society were sometimes completely sold out before the Private View was properly over.

Like Constable, he made constant use of small sketch books which could easily be carried in the pocket, and some of these, after his death, were sold at Christie's.

Most of his water colours were of small size* – some measuring no more than 4 in x 5 in wide. The only painting of Foster's on view in the English Water Colour Department at the Victoria and Albert Museum, entitled 'The Chair-Minder', cannot measure much more than 9 in x 12 in. It is really quite remarkable that he could put so much detail into so small a space.

* Martin Hardie states that the majority of his paintings were usually small, 'less than half Imperial size'.

Appreciation and Comment

A RECENT publication* listing most of the prominent names connected with water colour painting disposes of Birket Foster succinctly in the following terms: '. . . stippled sentimental landscapes with figures, genre. Exhibited 353 works: 332 at O.W.C.S.; 16 at R.A.; 2 at S.B.A.; (Works at Newcastle, Liverpool, V & A, B.M.'

Obviously none will accept this as the sum total of the artist's achievement: it is necessary to turn to a number of sources of information to obtain a proper assessment of his work both as an illustrator and a water colourist and in quoting a few of these it is hoped that the reader will be able to form his own opinion of the man and his life work.

First of all it seems to be the general view of modern critics that most of the artists practising either in oil or water colour during the time when Foster was most prolific, suffered from the fault of what can conveniently be described as 'overdoing'. As early as 1882 The Times, criticizing an exhibition of his work stated: '. . . he was practically the inventor of a style which consisted, at first, of minute execution with the finest point, and with the use of body colour, carried to an extent which, when he first practised it, was quite new. But this method obviously led him away from the qualities of breadth, rich tone of colour and translucent effect of light which belong to pure water colour. The same critic went on to say that he would be hard put to it to alter radically his original method of working. The *Art Journal* in its 1890 article, echoed *The Times* when it suggested that the artist was unconciously putting far too much substance and far too little mystery into his work.

But it was not altogether the fault of the 19th century water colourists that so many of them were regarded by succeeding artists and critics as fussy and detailed painters. For a long time the Academy exhibitions were the only ones at which a water colour artist could show his work and even here such pictures were usually relegated to inferior positions. They were regarded in the main as merely tinted drawings and as such treated with scant respect. In a misguided effort to remedy the situation and in order to compete with the oil painters the water colourists produced over elaborated works often enough shown in over elaborated frames.

It is true the Old Water Colour Society was founded in 1804 but the style which its members had been forced to adopt in order to present the public with the sort of pictures it seemed to want, persisted for many years right up to Birket Foster's time in fact.

Another aspect of Foster's work in both illustration and painting evoked criticism because of its tendency towards repetition of subject matter and the intrusion of too

* *A Dictionary of Water Colour Painters,* Stanley W Fisher. 1972.

much sugary sentiment. It could, of course, be contended that the publishers for whom the artist worked stipulated that degree of sentiment which characterized, for example, his drawings for the Magazine Christmas supplements – drawings which sometimes introduced pretty children too daintily dressed for the rustic scenes in which they were depicted.

It should not be necessary to take these comments too seriously for if Foster is to be found guilty of 'overdoing' then his friend Frederick Walker, and many other famous exponents of English landscape painting of the period, will not, in fairness, escape the stricture.

The best justification of Foster's attitude towards his choice of subject matter is that he naturally discovered beauty in everything. Wandering among the Surrey lanes he saw the average rustic as picturesque additions to the natural beauty of their surroundings. The labourer, if not modelled on the heroic type was, at all events, a sturdy fellow, a well set up family man whose wife and children possesed not only a homely beauty but an inborn gentility and grace. Some would say, indeed, that he went far towards popularizing the homes of humble country folk and their simple life in the fields: at least he was among the first to see and record beauty in the old wayside cottage with its mossy roof tiles and half-timbered walls half hidden in vines and honeysuuckle.*

Present-day artists are inclined to take short cuts in learning to paint and they appear reluctant to spend any time on those disciplines which a properly considered training demand. It is unusual for the modern student to study seriously the rules of perspective and composition and unless, as was the case with Birket Foster, the handling of composition comes naturally the resulting neglect is only too apparent. The writer of his life in the Dictionary of National Biography states simply, 'He was skilled in composition', and other writers express their admiration for his felicitous arrangement of line and harmonious distribution of light and shadow.

Reference has been made in an earlier part of this book to Foster's interest in Clarkson Stanfield's works, especially those which reveal his mastery of composition, and there is no doubt his close and sympathetic study of the latter's drawings and paintings was amply rewarded as time went on. In fact, it is believed that Birket Foster received little or no instruction in water colour painting and that in later years he was averse to giving instruction to others advising any who approached him in this matter to go away and study the masters, especially Turner.

Graham Reynolds in his book, *Victorian Painting* makes a comment which deserves mention in view of the accusations of 'overdoing' levelled at the artist. The writer, who had an opportunity of examining the sketch books at the Victoria and Albert Museum, refers to the drawings in them as having 'a breadth and calligraphic freedom which comes as a surprise to those who only know his finished work'. He refers in particular

* 'Birket Foster was one of the most typical artists of the mid-19th century. His rustic scenes and figures represent the sentimental close of the picturesque movement in this country'. Hesketh Hubbard. 1944.

to an 1860 painting, 'The Milkmaid'* which Birket Foster did at the age of thirty five and which represents, he considers, the artist's style 'before much repetition had made it careless'.

The late Colonel M H Grant refers to him with these words 'His pleasant, pretty work has long endeared him to those who ask no more from Art, and it is not a little'.

In Martin Hardie's monumental 3-Volume work, *Water Colour Painting in Britain,* (Vol. III), a tribute is paid to Birket Foster in these words: '. . . he manages always to hold sympathy and win fresh admirers and much of his work responded to the sentiment of the time . . . his pencil sketches are accurate, happy, observant, lively, while the figures and animals are searchingly and honestly drawn . . . his paintings contain a core of sound, honest craftsmanship'.

To conclude this brief chapter there can be no more appropriate comment on Foster than the one which Martin Hardie attributes to Sickert who is believed to have remarked, '. . . Oh, for one hour of Birket Foster . . . with his darling little girls playing at cat's cradle or figuring on their little slates . . . his children who bear the imprint of truth in every gesture'.

* This is illustrated herein.

His Circle of Friends

BIRKET FOSTER's frequent sorties into the countryside resulted in his becoming specially fond of the scenery of Surrey. He, and his friend Edmund Evans had often explored this part of the country together during painting expeditions and among the many beauty spots visited the village of Witley near Godalming, seemed to offer particular attractions. Eventually, during the summer of 1861 Foster secured possession of a charming old cottage called 'Tigburn', situated at the foot of Wormley Hill, Witley. To this cottage from St John's Wood he came during the summer months but it is evident that he found it too small and uncomfortable for permanent use and soon began looking about for something more suitable.

Reluctant to lose any time in the search he determined to build and after a while a site was discovered above the ground on which the cottage stood and here, by the year 1863 the house, known as 'The Hill' was completed and he, his old friend Edmund Evans and his wife (Birket Foster's niece), lived together for some months.

It must have been a memorable time for all concerned for Foster was virtually his own architect and the three of them must have watched with growing interest and pride the development of the building so much of which they had in one way and another supervised. It is said that in order to ensure the house blended in with the countryside material such as weather-worn bricks, tiles and timber were utilised where possible on the exterior and, of course, even more particular consideration was bestowed upon the decoration of the interior.

Birket Foster remarried in 1864 and probably his new wife found herself playing an important role in the choice of furnishings. It would seem that her husband directed the style of mural decoration for he consulted William Morris among other famous artists of the day and Burne Jones painted on canvas a frieze for the dining room illustrating the legend of St George.

About this time part of the site on which the house stood was sold to Edmund Evans who also built himself a home so that the two men were able to further cement their life-long friendship by becoming neighbours.

No need to ask why the Foster's home was called 'The Hill'. The house was ideally situated on an eminence below which a wonderful panorama opened to the view. To the right, over the rolling countryside and almost hidden by woods was Hindhead and on the left Blackdown, Haslemere and far beyond Petworth were the heights above Goodwood, Arundel and the range of the South Downs: even Chanctonbury Ring, on occasion, was visible. It would be difficult to imagine a more ideal spot in which to live.

But to return to the interior of 'The Hill' which Burne Jones did much to beautify the rooms when first completed must have been without the many paintings and

objets d'art which the Foster's acquired later on. Foster's collection of Turner's water-colour paintings in the drawing room were often admired together with examples of the work of his friends. His blue and white china was distributed throughout the bedrooms and people were well aware that he was among the first to recognise the worth and beauty of this type of china and to inaugurate the fashion for it. It would seem that Dante gabriel Rosetti was concerned in the establishment of this collection and contributed his full share of ideas for the embellishment of the place.

'The Hill' contained two studios, a large one which, since Foster had given up oil-painting, was seldom used, and a smaller one in which his water colours were produced. It was in the larger of these rooms that the plays which took place during so many years at Christmas, and which attracted a considerable amount of notoriety, were performed, but of this more later. There was a sizeable library containing early editions painstakingly acquired during the years and suitably housed in proper style.

No wonder that, as early as 1866 he found it necessary to enlarge the already spacious house by the addition of a large gable at the east end with a billiard room beyond it.

One of Birket Foster's most likeable traits was his sociability. Every one seems to have found in him those qualities which ensure enduring friendship. Edmund Evans and Frederick Walker in particular were his closest companions and Charles Keene, the artist whose drawings for *Punch* were so popular, revelled in the frequent visits they paid to 'The Hill'. Of course, the house was open to all Birket Foster's friends especially to his brother artists. Frederick Walker was a frequent visitor and was welcome at all times; his letters from there were full of glowing tributes not only to the beauty of its surroundings but also to his jovial host. It suited him so well, in fact, that he painted some of his most successful pictures in one of the rooms overlooking the Downs. William Orchardson, who was to be knighted in 1907, while staying at 'The Hill' suggested a subject for Walker when passing aged labourers sitting on a bench in the local churchyard and this picture, 'The Harbour of Refuge' was painted at Witley.

Christmas time was a period of great jollity at 'The Hill' – the time when Birket Foster most liked to have his friends around him. The house parties were always carefully planned: there would be an informal 'get together' as the guests assembled and from then on music and dancing at intervals during their stay. There is an account also of the members of one such party dressing up in sixteenth century costume which may have given rise to the idea of the amateur dramatics which were a feature of future parties from 1871 until 1878. There is no doubt that Birket Foster had a strong feeling for dramatic art and liked to display his versatility in this way. Frederick Walker soon took a leading part in these activities and painted the scenery on one or two occasions before his lamented death in 1875.

Apart from the events associated with 'The Hill' much of Birket Foster's reputation was centred in the village of Witley: the Parish church was the object of the Foster's benevolence in various ways, the village Institute was built by them at considerable

expense and even the village Inn, The White Hart, proudly accepted Foster's generosity by displaying a signboard specially designed and painted by him.

Life must have been very pleasant at this time living in such lovely surroundings and enjoying the companionship of his friends, but, in 1893 a serious illness brought about an unwelcome change. On the advice of his doctor he agreed to leave 'The Hill' and moved to Weybridge where, in the course of time, he resumed his painting.* In 1895, as already mentioned, he was elected at the age of seventy, a member of the Royal Academy of Berlin and certainly during the following years was not only painting but keeping himself au fait with affairs and exhibitions in London.

But on the 27th March 1899 Birket Foster died and five days later was buried in Witley churchyard. None felt his passing more keenly than his old friend Edmund Evans who had known him since he was fifteen. He left his wife, three sons and two daughters?

Birket Foster would scarcely rank as a 'great' artist but, as we have seen, he at least succeeded in winning great esteem not only among his immediate contemporaries but in wider circles of artistic appreciation. He painted, with love and enthusiams and displayed a pure feeling, in particular, for English landscape and a high perception of the beauty of Nature, and his pleasant pretty work has long endeared him to those who ask no more from Art, and it is not a little.

* As the list of paintings shows, he exhibited 4 paintings at the RWS's Summer exhibition of 1893 and 9 paintings the following year, not to mention the Winter exhibitions.

Pictures exhibited at the
Royal Academy 1859–1881

1859 A Farm: Arundel Park in the Distance (Water-colour)

1869 A Surrey Lane (Oil)

1870 Dunstanborough Castle (Oil)

1871 The Thames near Eton (Oil)
 The Bass Rock (Oil)

1872 Over Sands (Oil)
 The Ford (Oil)

1873 In the Isle of Wight (Oil)
 A Pedlar (Oil)

1874 A Lifeboat: A Return from the Wreck (Oil)
 The Brook (Oil)

1875 On the River Mole – Evening (Oil)

1876 A Peep at the Hounds (Oil)

1877 A Brook (Oil)

1881 The Wandering Minstrel (Etching)

Pictures exhibited at the Society of Painters in Water Colours 1860–1899

The first time Birket Foster's work was shown, viz. at the Society's 56th Exhibition in 1860, at the Gallery, 5 Pall Mall East, London S.W. The Gallery is advertised in the catalogue as being open from nine till dusk. 'Admittance one shilling'. Catalogue sixpence.

Birket Foster listed as 'Associate' at 12 Carlton Hill East, St John's Wood. The following pictures were shown:

1860 (Summer Exhibition)
 Feeding the Ducks
 View in Holmwood Common
 Children going to School
 View on the River Mole

1861 (Summer Exhibition) Birket Foster still 'Associate'
 Wark's Burn, Northumberland
 Gleaners
 Down Hill
 Cattle in the Stream
 A Cottage
 Burnham Beeches

1862 (Summer Exhibition) Birket Foster still 'Associate'), same address
 A Lock
 The Bird's Nest
 Fishing
 The Little Nurse
 Water-Lilies *(see plate 7)*
 The Dairy Bridge, Rokeby
 On the Shore, Bonchurch, Isle of Wight
 A Fisherman's Cottage, Isle of Wight

1862/63 (Winter Exhibition)
 Edinburgh Castle
 Studies of Skies
 Studies of Skies

1863 (Summer Exhibition) Birket Foster shown as 'Member',
 address: Witley, Surrey

 The Ferry

 A Village Maiden
 Lane Scene, Hambledon
 At Hambledon, Surrey
 Hay-Carts
 Near Peterborough
 Collier Unloading
 Cottage at Chiddingfold
 River Scene – Evening

1863/64 (Winter Exhibition)
 At Pinner
 Rocks
 Lobster Pots
 Brighton Boats
 At Bonchurch
 Ryde
 Queensferry
 Rock
 The Spring
 Near Littlehampton
 Marsden
 Dunstanboro'
 Newhaven
 Firth of Forth
 Queensferry
 At Bonchurch
 Craigmillar Castle
 Dunblane
 Craigmillar

1864 (Summer Exhibition)
 Flying a Kite
 The Donkey Ride *(see plate 5)*
 River Scene
 Cattle Drinking
 Morning
 Evening
 Sunset

The Wooden Bridge
Sand-Cart

1864/65 (Winter Exhibition)
Hitchin Market Place

Near Streatley
Haslemere
A Tree Stem
Preston, Sussex
Streatley
Richmond Park
The Ferry
Barnburgh Castle
River Mole
River Mole
Old Barn
On Hampstead Heath
Saltburn-on-Sea
Study of Ferns
Ingleton
Lucerne
Cottages at Hambledon
Near Dorking
Ben Lomond
Near Barnard Castle
Ben Venue
River Scene
A Barn Roof
Sheep
Cottages at Chiddingfold
Chiddingfold Church
The Mill

1865 (Summer Exhibition)
On the Beach, Hastings
Primroses
The Shrimper
Expectation
The Lesson
The Bird's Nest
'To gather king cups in the yellow mead

29

and prink their hair with daisies'
The Swing

1865/66 (Winter Exhibition)
 Four Studies of Village Children

1866 (Summer Exhibition)
 River Scene, Evening
 Winterbourne, Bonchurch, Isle of Wight

1866/67 (Winter Exhibition)
 Cottagers
 Trees
 Skies

1867 (Summer Exhibition)
 Bellagio, Lake of Como
 The Old Breakwater
 Old Shoreham Bridge
 The Dead Jay
 The Way down the Cliff
 York

1867/68 (Winter Exhibition)
 Rocks at Barnard Castle
 Tees High Force
 Weir at Barnard Castle
 At Marsden
 Newbiggin by the Sea

1868 (Summer Exhibition)
 The Mole, near Bletchworth
 The Convalescent
 Snowdrops
 The Donkey
 The Little Chickens

1868/69 (Winter Exhibition)
 Study of Sea, Northumberland Coast
 Study of Hay
 Timber
 Lock, Stratford-on-Avon
 The Peacock
 The Rabbit Hutch

In the Wood
Beech Stem – Autumn

1869 (Summer Exhibition) Birket Foster's address from now on, 'The Hill',
 Witley, Surrey

The Meet
A Breakwater

A Mill Pool
Village Children
A River Scene

1869/70 (Winter Exhibition)
Grand Canal
Study of Pots and Girl at a Well, St Remo
House on the Grand Canal, Venice
Edinburgh Castle
Basket of Cowslips
Barresford, North Tyne
Pangbourne
Autumn Studies
Richmond, Yorkshire
Loch Lomond
Creels
Cottage at Cullercoats
Haughton Castle, North Tyne
The Brook at Barrasford

1870 (Summer Exhibition)
The Wealds of Surrey
Burnham Beeches

1870/71 (Winter Exhibition)
The Greta at Rokeby
Houses at Eton
Burnham Beeches
In the Woods at Burnham
Eton College
Beach Tree
A Cottage Door
Eel Pots
Cottage at Bray
On the Thames near Eton

31

Roses

Nasturtiums

1871 (Summer Exhibition)

The Valley of the Tyne

Greta Bridge, Yorkshire

River Scene with Barges

On the Thames Nr. Eton

Rabbits

Hay Barges

River Scene with Sheep

Old Walton Bridge on the Thames

Cowslips

1871/72 (Winter Exhibition)

Stratford-on-Avon

Morecombe Bay

Dunstanboro'

The Thames at Eton

The Falls of the Tummel

Edinburgh

Dead Gull

The Bass Rock

Newcastle, from Gateshead Fell

Newcastle and the River Tyne

River Bank

The Punt

On the Garry

Cottage at Tarbet

Lancaster

Highland Cottage

Loch Tummel

Sunflowers

Nasturtiums

Dunblane

1872 (Summer Exhibition)

Haymakers

The Village Inn

St Michael's Mount

1872/73 (Winter Exhibition)

St Andrews

At Salisbury

1873 (Summer Exhibition)
 Melrose, Dryburgh, Abbotsford
 Bereft

1873/74 (Winter Exhibition)
 Turin
 Study

 Shoreham
 At Verona
 A Fruiterer's Shop
 A Well at Hastings
 Flowers
 Study of Fish
 A Pike

1874 (Summer Exhibition)
 Lausanne, Lake of Geneva
 The Spring
 The Return of the Lifeboat
 Antwerp
 Bridge over the Moselle, Coblenz

1874/75 (Winter Exhibition)
 Calais
 St Andrews
 Rye
 Studies of Fish
 Cologne
 In a Farmyard
 On Lake Como

1875 (Summer Exhibition)
 A Cottage
 Fish Stall at Venice
 A Shrine, Venice
 Alsatian Flower-Girl

1875/76 (Winter Exhibition)
 Study of the Sea
 Woodland Scene
 A Foot-Bridge
 A Pig Stye
 On Hambledon Common

1876 (Summer Exhibition)
 A Donkey that wouldn't go
 In the Market at Toulon
 Exercising the Hounds
 Fountain at Toulon

1876/77 (Winter Exhibition)
 Dunbar Castle

1877 (Summer Exhibition)
 The Capture of a 32-Pounder *(see plate 17)*
 A Chair Mender *(see plate 9)*

1877/78 (Winter Exhibition)
 Market at Dinan
 Women Washing on the Loire
 Loch Leven
 In the Church of St Melaine, Morlaix, Brittany
 On the Thames at Caversham
 St Andrews
 Thames near Eton
 On the Stour
 The Thames at Shiplake

1878 (Summer Exhibition)
 Venice
 A New Purchase

1878/79 (Winter Exhibition)
 The Fountain of Drannee, Brittany
 Rouen Cathedral
 On the Common, Hambledon
 A Sketch at Haddon Hall
 Fruit Stall near the Rialto, Venice
 The Letter

1879 (Summer Exhibition)
 The Wandering Minstrels
 The Falls of the Tummel

1879/80 (Winter Exhibition)
 On the Coquet at Warkworth
 The Thrum, on the Coquet at Rothbury
 A North-Country Stile
 Riverside near Warkworth

1880 (Summer Exhibition)
 Venice from the Guidecca
 West Portal of Rheims Cathedral
 The Cornfield

1880/81 (Winter Exhibition)
 Cattle in Water
 On Hambledon Common
 Stepping Stones
 Bridge near Dartmouth, Devon
 Dittisham on the Dart
 Feeding Geese
 Stream at Bedgellert, North Wales
 Shelling Peas
 Cottage near Tenby

1881 (Summer Exhibition)
 The Stepping-Stones
 An Old Water-Mill

1881/82 (Winter Exhibition)
 St Gervaise, Falaise – Market Day
 Falls of the Tummel, Perthshire
 A Welsh Stile
 Lyme Regis (two views)

1882 (Summer Exhibition)
 Turnberry Castle, Ayrshire. Early home of Robert Bruce.
 The Watering Place

1882/83 (Winter Exhibition)
 An Old Water-Mill
 Fish and Fruit
 Lancaster
 The Brook
 David Cox's Cottage, Bettwys-y-Coed

1883 (Summer Exhibition)
 A Surrey Landscape
 Clovelly

1883/84 (Winter Exhibition)
 Cottage at Banavie, Inverness
 Highland Bridge, Lochearnhead
 Ben Nevis

The Angler
The Kingfisher

1884 (Summer Exhibition)
A Lane near Dorking *(see plate 8)*
Passing the Flock *(see plate 4)*
A Windfall
An Itinerant Musician
Gypsies

1884/85 (Winter Exhibition)
In the Western Highlands (three drawings)
A Surrey Cottage

1885 (Summer Exhibition)
The Dipping-Place

1885/86 (Winter Exhibition)
Ben Venue from Loch Achray
Highland Scene near Dalmally
A Highland Cottage

1886 (Summer Exhibition)
The Hermitage Bridge, Dunkeld
Seville
Sandpits, Hambledon Common
Buttercups

1886/87 (Winter Exhibition)
Girl at a Brook – Western Highlands
Loch Awe
A Highland Cottage
Bridge near Dalmally

1887 (Summer Exhibition)
The Lock

1887/88 (Winter Exhibition)
Autumn Leaves
Highland Cottage near Connel Ferry
In Canty Bay
A Spanish Gypsy
Cottage at Sidmouth
Flowers and Fruit (three subjects)
Runswick

Crab and Lobster
The Old Pier
A Cottage
A Farm

1888 (Summer Exhibition)
In the Market-Place, Verona

1888/89 (Winter Exhibition)
A Lacemaker
Abandoned
Study of Rocks, Gairloch
Study of Rocks
A Boat, Gairloch
Old Cottages, Hambledon
Sheep and Lambs
Crofters' Cottages, Gairloch
Sketch in Hambledon, Surrey
Cottage in Talladale, Loch Maree
A Cottage, Hambledon
At Gairloch

1889 (Summer Exhibition)
Ruined Cottage, at Gairloch
A Surrey Lane
Ben Venue and Ellen's Isle, Loch Catrine
A Surrey Farm
A Cottage on Hambledon Common
Cottages at Gairloch, Ross-shire
In the Cathedral of S Sauveur, Dinan, Brittany
Washing-Place, near Quimper, Brittany

1889/90 (Winter Exhibition)
A Highland Village, Loch Alsh
Cottage near Balmacara
Collier Unloading
Haytime
Harvest-Time, Loch Duich
A Highland Burn, Balmacara
Oats, Balmacara
A Highland Cottage, Loch Alsh
A Misty Day, Loch Alsh, Ross-shire
At Balmacara, Skye in the distance

1890 (Summer Exhibition)
 Arrival of the Hop-Pickers, Farnham *(see plate 22)*
 A Surrey Lane
 Runswick, Yorkshire

1891 (Summer Exhibition)
 A Knife-Grinder
 Ben Nevis
 In a Garden at Sorrento

1891/92 (Winter Exhibition)
 Fisherman's Cottage, Gairloch
 On the Shore, Gairloch
 Cottages at Gairloch
 Near Loch Etive
 A Fisherman's Garden, Runswick
 A Surrey Lane
 The Sun-Dial

1892 (Summer Exhibition)
 Loch Maree
 The Footpath by the Water Lane
 Oranges and Lemons, Mediterranean

1892/93 (Winter Exhibition)
 A Highland Stream
 Bridge over the Cluny, Braemar
 A Highland Water-Mill
 On Hambledon Common
 On the River Cluny, Braemar
 Near Bonchurch, Isle of Wight
 An Old Mill near Braemar
 A Girl at the Spring
 Cottage near Bonneavie
 Old Pier, St Andrews

1893 (Summer Exhibition)
 'To gather Kingcups in yellow mead,
 and prink their hair with daisies'
 In Glencoe
 Fast Castle, 'The Wolf's Crag' of The Bride of Lammermoor
 An Old Fiddler

1893/94 (Winter Exhibition)
 The Model
 Near Braemar
 At Calborne, Isle of Wight
 Barking
 Under the Beech Tree
 Fraser's Bridge, Braemar
 Milton's Cottage, Chalfont St Giles
 Cottages, Dalmally
 Downey's Cottage, Braemar
 Cottage at Braemar

1894 (Summer Exhibition)
 A Cottage at Taynuilt
 A Market at Seville
 In a Wood, Witley
 In a Garden at Sorrento
 Fisherman's Cottage, North Berwick
 Freshwater Bay
 Near Freshwater, Isle of Wight
 On Hambledon Common
 Cottage at Ballater

1894/95 (Winter Exhibition)
 Cottage at Kimbolton
 A Suffolk Well
 The Stream at Wornditch, Kimbolton
 'June' – In a Cottage near a Wood
 The Old Pier, Walberswick
 On the Beach, Southwold
 A Windlass, Southwold
 At Wornditch, Kimbolton
 Walberswick, Suffolk

1895 (Summer Exhibition)
 Horning Ferry, Norfolk
 Near Ballater
 Procession on Pardon Day, Quimper, Brittany
 A Little Court-yard in the Alhambra
 At Walberswick, Suffolk

1895/96 (Winter Exhibition)
 Near Connel Ferry

An Orphan
Butterflies
The Village Tree
The Island of Mull, from Oban
Cottages at Taynuilt
A Highland Cottage
Cottage near Connel Ferry

1896 (Summer Exhibition)
Walberswick
In a Garden at the Alhambra
Schrachan, Taynuilt
A Girl at a Stream
On Hambledon Common
Waiting for the Ferry
Southwold from the Black Quay

1896/97 (Winter Exhibition)
On the Canal, Weybridge
Highland Cottage, near Taynuilt
Burano, Venice *(see plate 38)*
Loch Etive, from near Conel Ferry
A Farm, Connel Ferry
Ben Cruachan
Near Taynuilt
Roses

1897 (Summer Exhibition)
Wild Flowers
Near Connel Ferry
Crofters' Cottages at Strath, Gairloch

1897/98 (Winter Exhibition)
A Highland Cottage
The Alhambra
A Roadside Shrine near Genoa
A Rest by the Way
Haytime
A Stream
At Connel Ferry

1898 (Summer Exhibition)
Ben Ledi from Callender

1898/99 (Winter Exhibition)
 On the River Spean
 The Pet Lamb
 Roy Bridge, Inverness-shire
 Loch Etive
 Highland Cottage near Taynuilt
 Old Cottages, Loch Etive
 Cottage near Taynuilt
 Cottage near Connel Ferry

1899 (Summer Exhibition)
 A Milkmaid, Arisaig

1841 IRELAND, ITS SCENERY, CHARACTER, ETC.
 by Mr. & Mrs. S. C. Hall

1845 ALDERSHOT AND ALL ABOUT IT
 BIRDS, TREES, AND BLOSSOMS
 RICHMOND AND OTHER POEMS
 by C. Ellis

1847 THE BOY'S SPRING BOOK
 by Thomas Miller
 THE BOY'S SUMMER BOOK
 by Thomas Miller
 THE BOY'S AUTUMN BOOK
 by Thomas Miller
 THE BOY'S WINTER BOOK
 by Thomas Miller

1848 THE FEMALE WORKER TO THE POOR

1849 THE RIVER THAMES
 by J. F. Murray

1850 THE PILGRIMS OF THE RHINE
 by Sir E. B. Lytton

 EVANGELINE: A TALE OF ACADIE
 by Henry Wadsworth Longfellow
 THE YEAR OF THE COUNTRY; OR THE FIELD, THE FOREST,
 AND THE FIRESIDE
 by W. Howitt
 ORIGINAL POEMS FOR MY CHILDREN
 by Thomas Miller

1851 CHRISTMAS WITH THE POETS
 THE MOORLAND COTTAGE
 by the Author of Mary Barton
 THE ILLUSTRATED BOOK OF SONGS FOR CHILDREN
 VOICES OF THE NIGHT
 by H. W. Longfellow
 THE POETICAL WORKS OF OLIVER GOLDSMITH

1852 LONGFELLOW'S POETICAL WORKS
THE STORY OF MONT BLANE
 by Albert Smith
A MONTH AT CONSTANTINOPLE
 by Albert Smith

1853 FERN LEAVES FROM FANNY'S PORTFOLIO
POETRY OF THE YEAR
THE LADY OF THE LAKE
 by Sir Walter Scott
THE LAY OF THE LAST MINSTREL
 by Sir Walter Scott
A HOLIDAY BOOK FOR CHRISTMAS AND THE NEW YEAR
A PICTURESQUE GUIDE TO THE TROSSACHS

1854 PROVERBIAL PHILOSOPHY
 by Martin Tupper
THE BLUE RIBBON; A STORY OF THE LAST CENTURY
 by Anna Harriet Drury
AN ELEGY WRITTEN IN A COUNTRY CHURCHYARD
 by Thomas Gray
LITTLE FERNS FOR FANNY'S LITTLE FRIENDS
L'ALLEGRO AND IL PENSEROSO
 by John Milton
THE GOLDEN LEGEND
 by Henry Wadsworth Longfellow

1855 MARMION
 by Sir Walter Scott
THE RHINE AND ITS PICTURESQUE SCENERY
 by Henry Mayhew
THE DAIRYMAN'S DAUGHTER

1856 SABBATH BELLS CHIMED BY THE POETS
THE TASK
 by William Cowper
THE TRAVELLER
 by Oliver Goldsmith
MIA AND CHARLIE
THE POETICAL WORKS OF GEORGE HERBERT
SACRED ALLEGORIES
 by the Rev. W. Adams

1857 THE SABBATH; SABBATH WALKS
 by James Grahame
 THE POETS OF THE NINETEENTH CENTURY
 Selected & edited by the Rev. R. A. Willmott
 MINISTERING CHILDREN
 THE RIME OF THE ANCIENT MARINER
 by Samuel Taylor Coleridge
 RHIMES AND ROUNDELAYS IN PRAISE OF A COUNTRY LIFE
 THE COURSE OF TIME
 by R. Pollok
 DRAMATIC SCENES AND NEW POEMS
 by Barry Cornwall
 THE LORD OF THE ISLES
 THE FARMER'S BOY
 by Robert Bloomfield

 THE UPPER RHINE: THE SCENERY OF ITS BANKS AND THE
 MANNERS OF ITS PEOPLE
 described by Henry Mayhew

1858 POEMS OF WILLIAM BRYANT
 THE POETICAL WORKS OF EDGAR ALLEN POE
 COMUS
 by John Milton
 THE PRINCE OF PEACE; OR, LAYS OF BETHLEHEM
 THE HOME AFFECTIONS PORTRAYED BY THE POETS
 Selected & edited by Charles Mackay
 KAVANAGH: A TALE
 by Henry Wadsworth Longfellow
 POETRY AND PICTURES FROM THOMAS MOORE
 THE SHIPWRECK
 by Robert Falconer
 THE GRAVE
 by Robert Blair
 LAYS OF THE HOLY LAND; FROM ANCIENT AND MODERN
 POETS

1859 THE SEASONS
 by James Thomson
 THE MERRIE DAYS OF ENGLAND
 by Ed. McDermott

POEMS AND SONGS
by Robert Burns
POEMS BY WILLIAM WORDSWORTH
by Robert Aris Willmott
THE HAMLET
by Thomas Warton
THE POETICAL WORKS OF THOMAS GRAY
FAVOURITE ENGLISH POEMS
THE POEMS OF OLIVER GOLDSMITH
edited by Robert Aris Willmott
THE DESERTED COTTAGE
by William Wordsworth
THE WHITE DOE OF RYLSTONE
by Henry Wadsworth Longfellow

1860 CHILDE HAROLD'S PILGRIMAGE
by Lord Byron
THE TEMPEST
by William Shakespeare
THE MERCHANT OF VENICE
by William Shakespeare
THE POETS OF THE WEST
COMMON WAYSIDE FLOWERS
by Thomas Miller
POEMS BY JAMES MONTGOMERY
A BOOK OF FAVOURITE MODERN BALLADS
LALLAH ROOKH
by Thomas Moore
SONGS FOR MY LITTLE ONES AT HOME

1862 THE SCOTTISH REFORMATION
by Peter Lorimer

1863 ODES AND SONNETS

1867 SUMMER SCENES

1872 POEMS
by Thomas Hood

1873 THE TRIAL OF SIR JASPER
by S. C. Hall

Bibliography

	—	ART JOURNAL 1871 & Christmas number, 1890
	—	ART NEWS 1910
Cundall, H. M.	—	BIRKET FOSTER, R.W.S. (A. & C. Black, 1906)
—	—	DICTIONARY OF NATIONAL BIOGRAPHY
Fisher, Stanley	—	DICTIONARY OF WATER COLOUR PAINTERS (1972)
Glasson, L.	—	OLD WATER COLOUR SOCIETY'S CLUB. Vol. XI (1933)
Hardie, Martin	—	WATER COLOUR PAINTING IN BRITAIN. Vol. 3
Hubbard, Hesketh	—	SOME VICTORIAN DRAUGHTSMEN (1944)
Huish, Marcus	—	BIRKET FOSTER – HIS LIFE & WORK (1890)
Long, Basil	—	CATALOGUE OF WATER COLOUR PAINTINGS (V. & A. Museum)
Paviere, S. H.	—	DICTIONARY OF VICTORIAN LANDSCAPE PAINTERS (1968)
Pennell, Joseph	—	MODERN BOOK ILLUSTRATORS (1895)
—	—	THE PORTFOLIO (1891)
Reynolds, Graham	—	VICTORIAN PAINTING (1966)
—	—	ENGLISH WATER COLOUR (Studio, 1902)
Thomson, Hugh	—	HIGHWAYS & BYWAYS IN SURREY (1908)

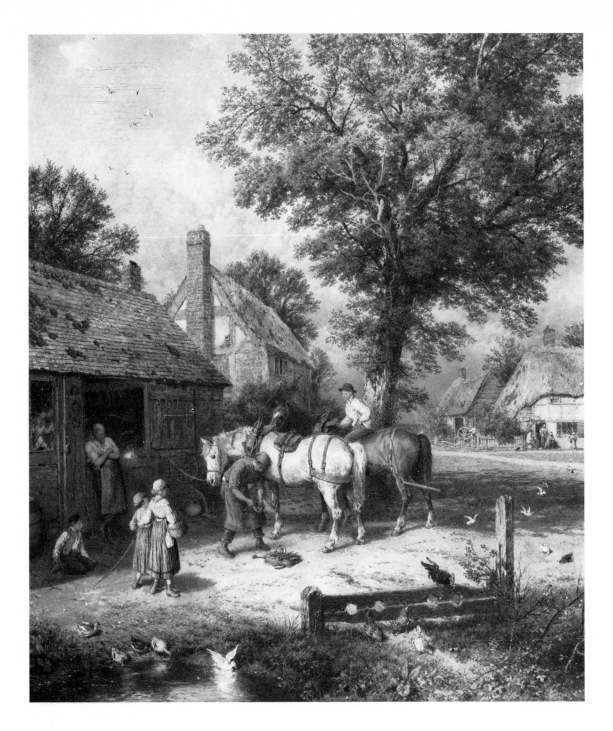

Water-colour THE SMITHY 30 x 26 in.
Courtesy, Frost & Reed Ltd., Bristol and London

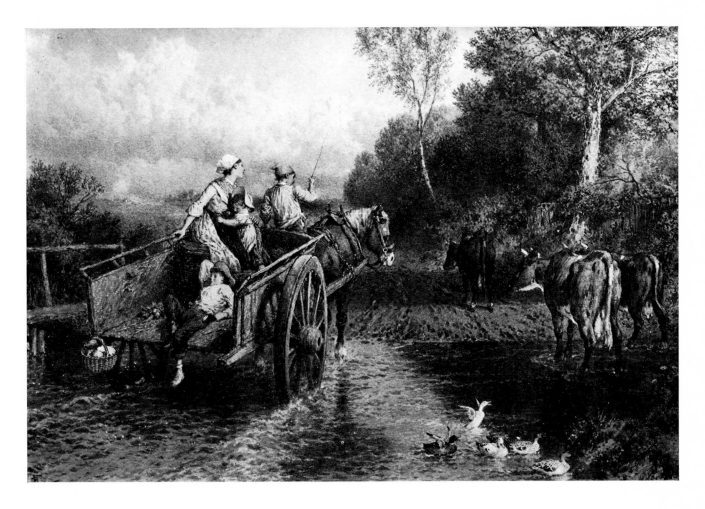

Water-colour **RETURNING FROM MARKET** 10 x 14 in.
Courtesy, M. Newman Ltd., London

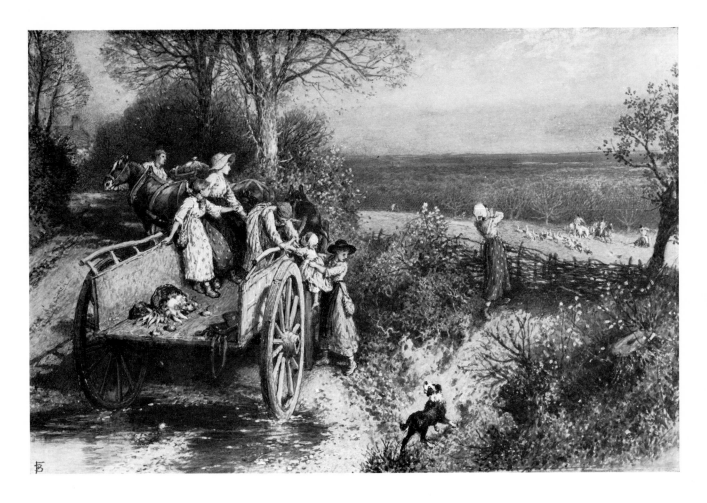

Water-colour A PEEP AT THE HOUNDS 9 x 14 in.
Courtesy, M. Newman Ltd., London

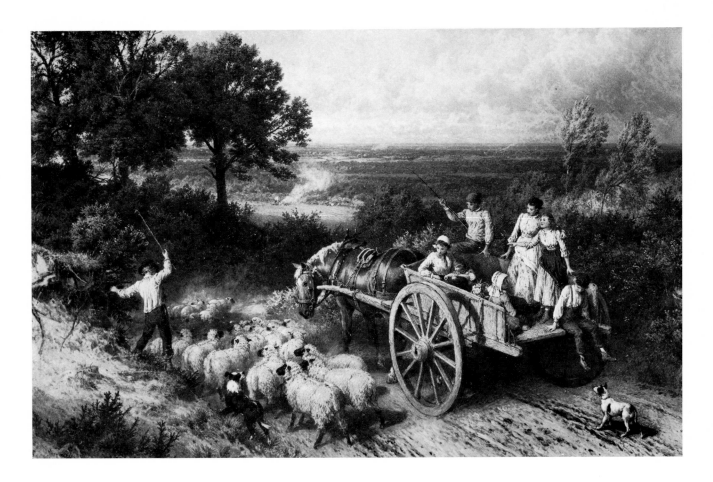

Water-colour

PASSING THE FLOCK
Courtesy, Richard Green Fine Paintings, London

$20\frac{3}{4}$ x $31\frac{3}{4}$ in.

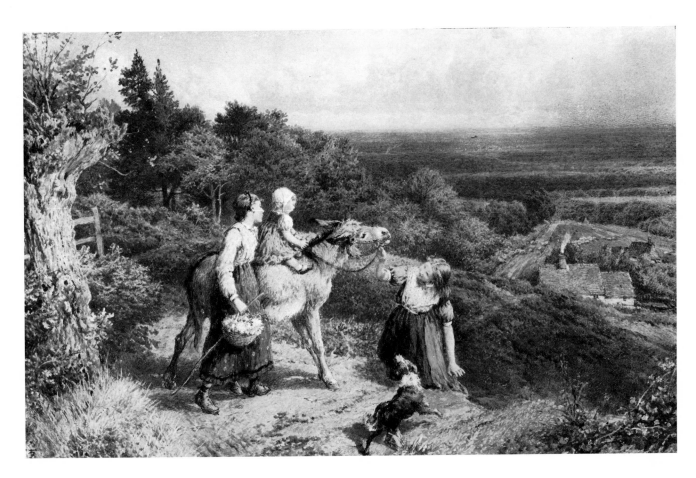

Water-colour THE DONKEY RIDE $10\frac{1}{2}$ x $16\frac{1}{4}$ in.
Courtesy, Richard Green Fine Paintings, London

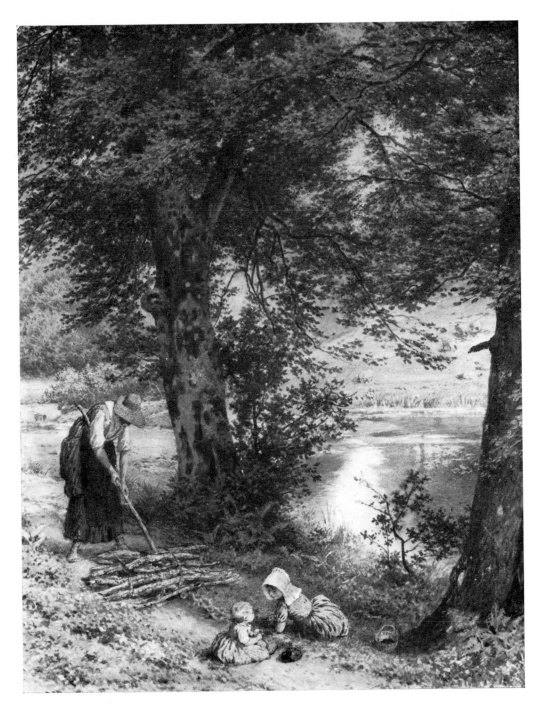

Water-colour GATHERING FUEL, SURREY $12\frac{1}{2}$ x $10\frac{1}{4}$ in.
Courtesy, Frost & Reed Ltd., Bristol and London

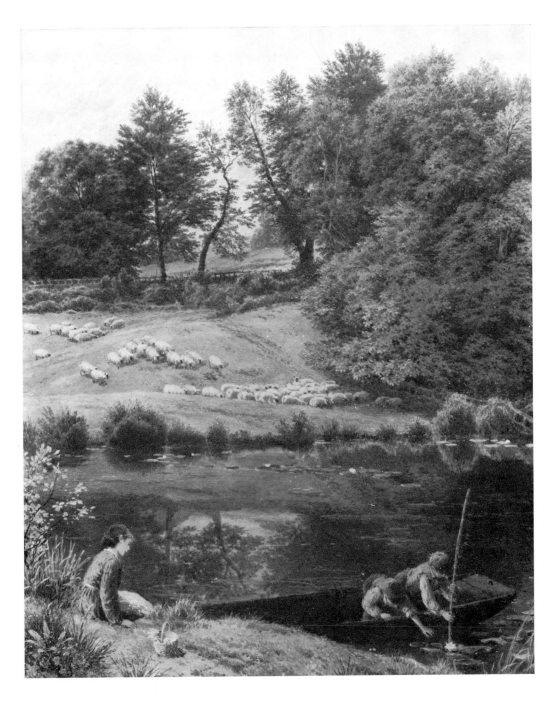

Water-colour WATER LILIES $17\frac{3}{4}$ x $14\frac{3}{4}$ in.

Courtesy, Frost & Reed Ltd., Bristol and London

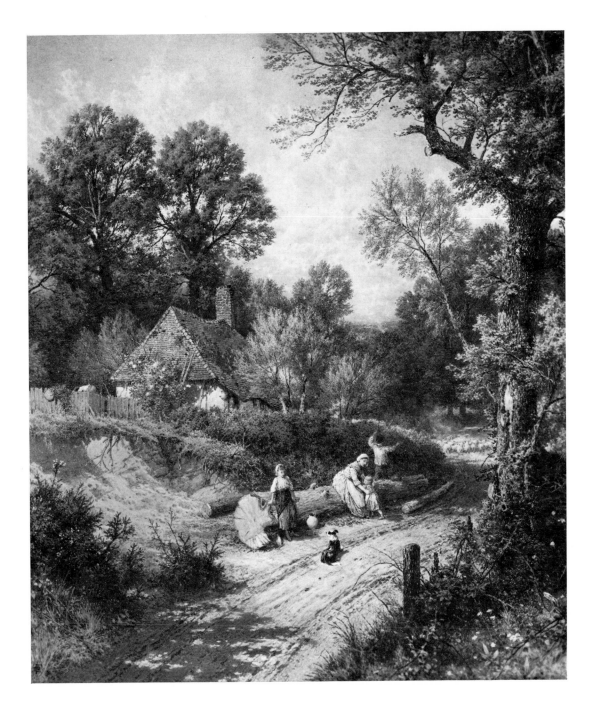

Water-colour LANE NEAR DORKING $30\frac{1}{2}$ x $26\frac{1}{2}$ in.

Courtesy, The Fine Art Society Ltd., London

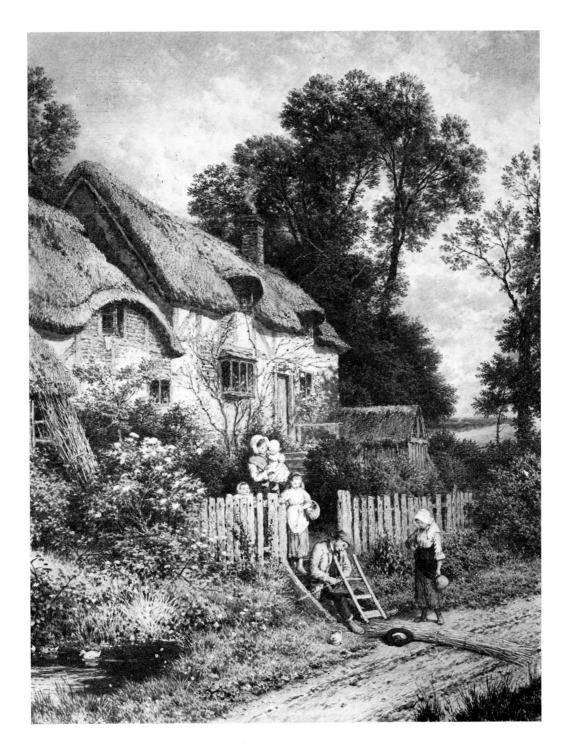

Water-colour THE CHAIRMENDER $17\frac{3}{4}$ x $13\frac{3}{4}$ in.

Courtesy, The Fine Art Society Ltd., London

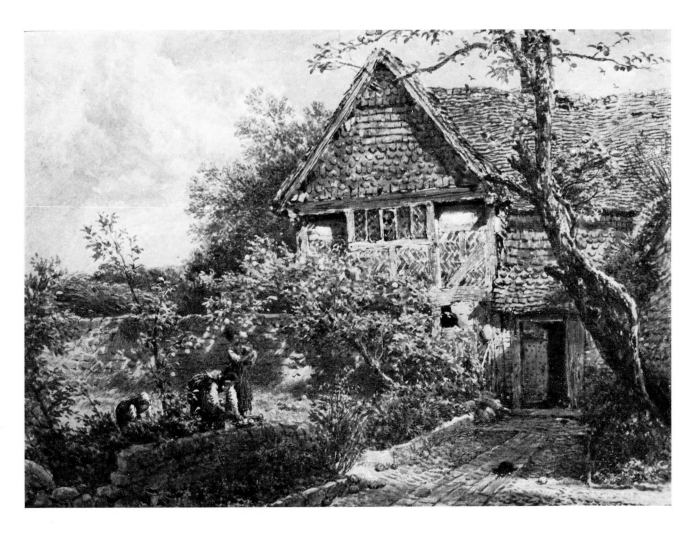

Water-colour

FRUIT PICKING
Courtesy, The Leger Galleries Ltd., London

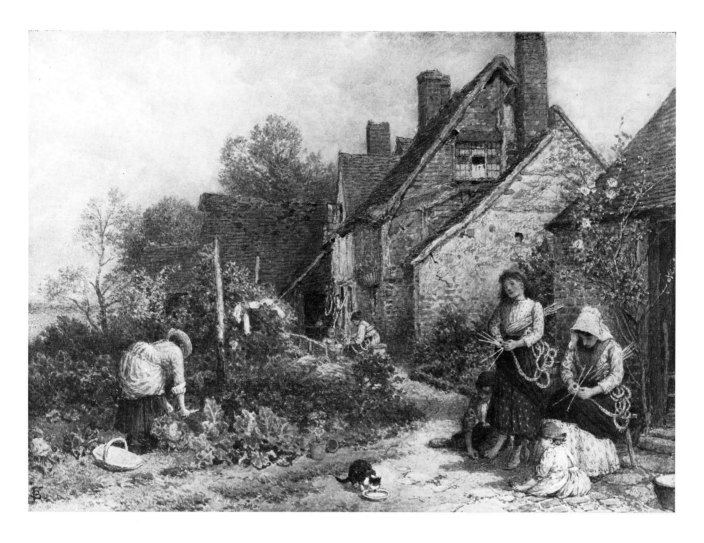

Water-colour STRAW PLAITERS, AMERSHAM 8 x 11 in.
Courtesy, M. Newman Ltd., London

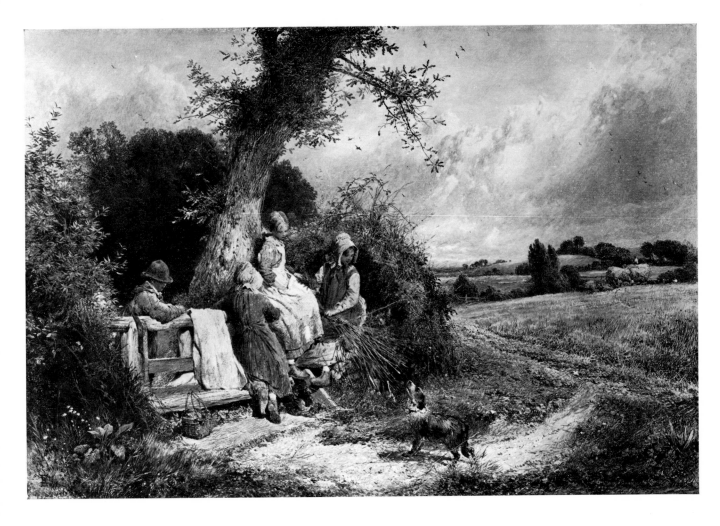

Water-colour YOUNG GLEANERS RESTING $11\frac{7}{8}$ x $17\frac{7}{8}$ in.

Courtesy, Victoria & Albert Museum, London

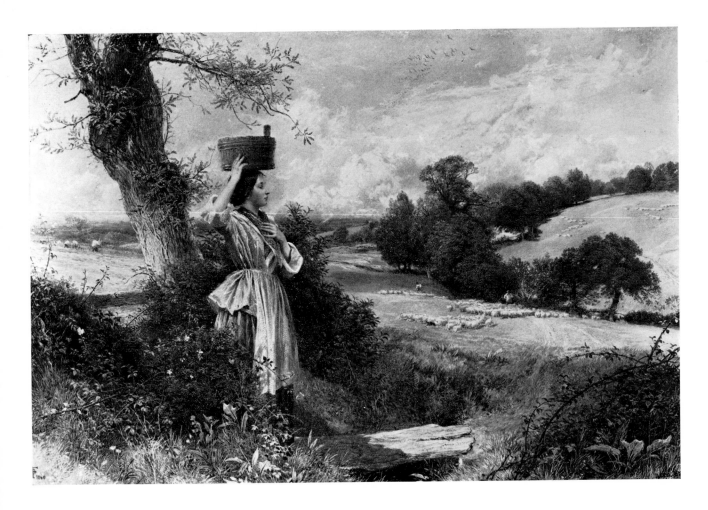

Water-colour
THE MILKMAID. S & D 1860
Courtesy, Victoria & Albert Museum, London
$11\frac{3}{4}$ x $17\frac{1}{2}$ in.

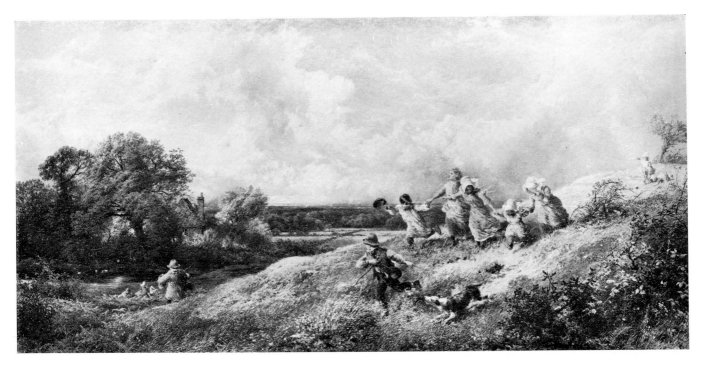

Water-colour CHILDREN PLAYING $13\frac{1}{4}$ x $27\frac{5}{8}$ in.
Courtesy, Victoria & Albert Museum, London

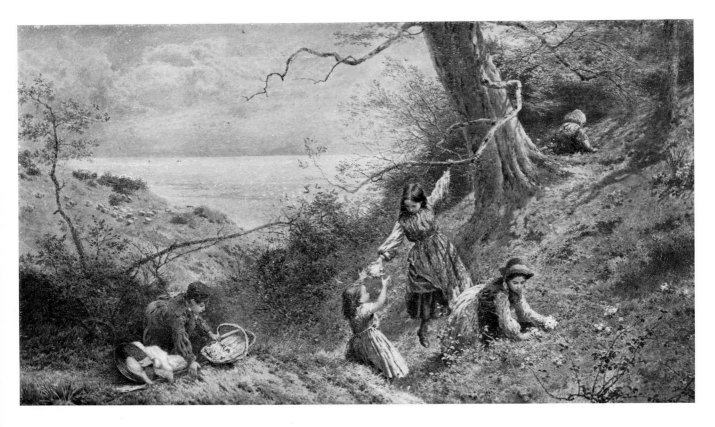

Water-colour PRIMROSE GATHERERS 13 x $23\frac{1}{2}$ in.
Courtesy, M. Newman Ltd., London

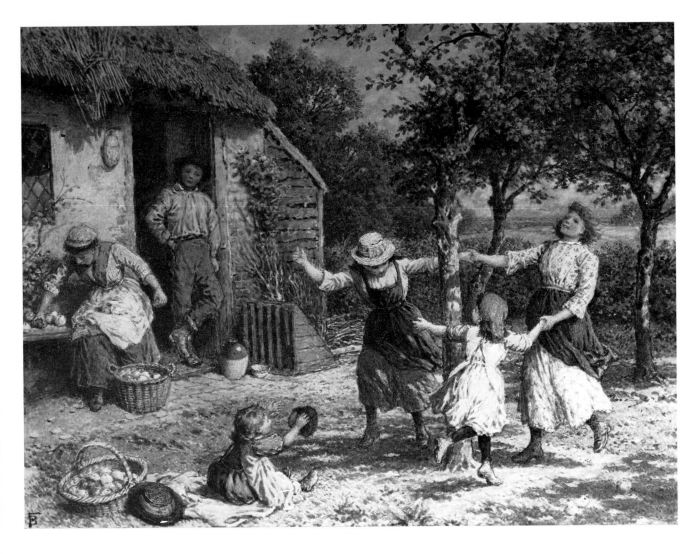

Water-colour CHILDREN PLAYING OUTSIDE A COTTAGE $8 \times 10\frac{5}{8}$ in.

Courtesy, M. Newman Ltd., London

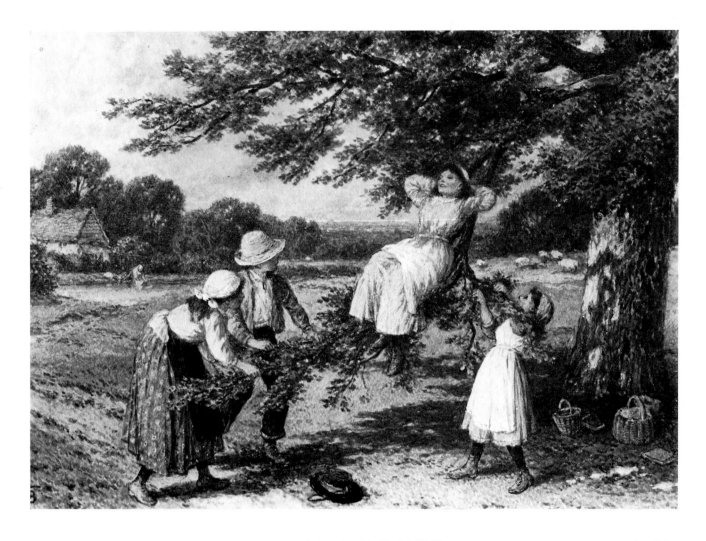

Water-colour THE IMPROVISED SWING 6 x 8 in.

Courtesy, M. Newman Ltd., London

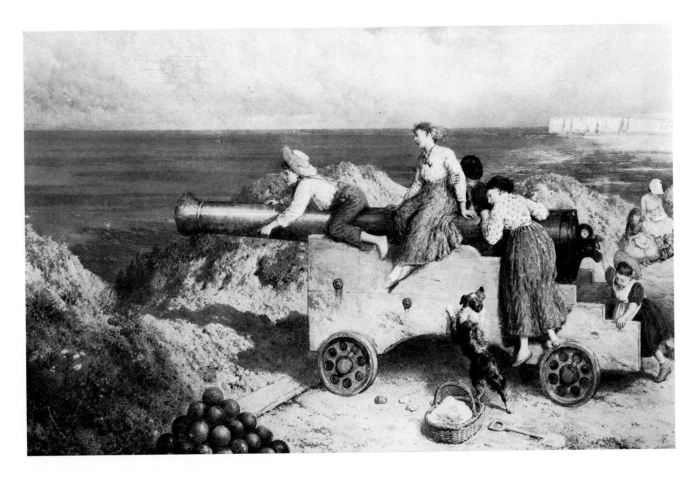

Water-colour MARGATE : CAPTURE OF THE 32 POUNDER $17\frac{1}{2}$ x $27\frac{1}{2}$ in.
Courtesy, The Leger Galleries Ltd., London

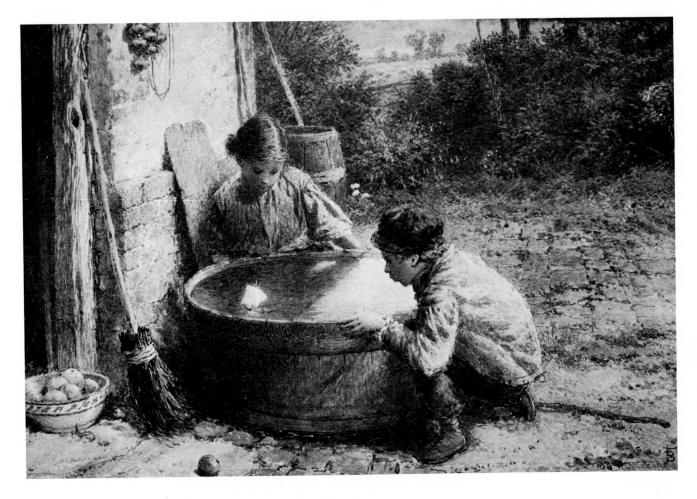

Water-colour THE TOY BOAT 6 x 8¾ in.
Courtesy, M. Newman Ltd., London

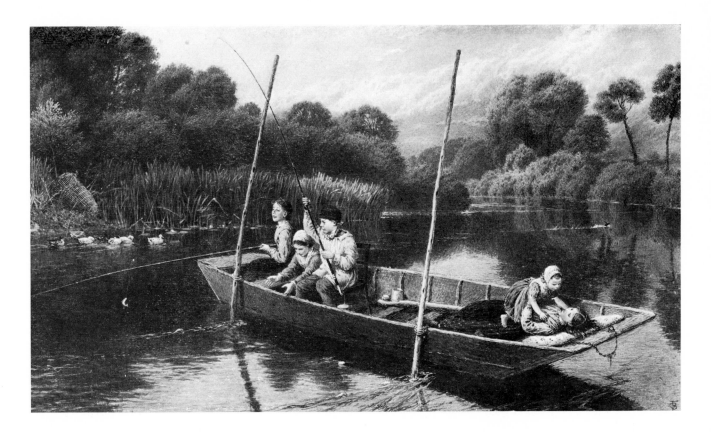

Water-colour CHILDREN ANGLING IN A PUNT ON THE THAMES 14 x 24 in.
Courtesy, Richard Green Fine Paintings, London

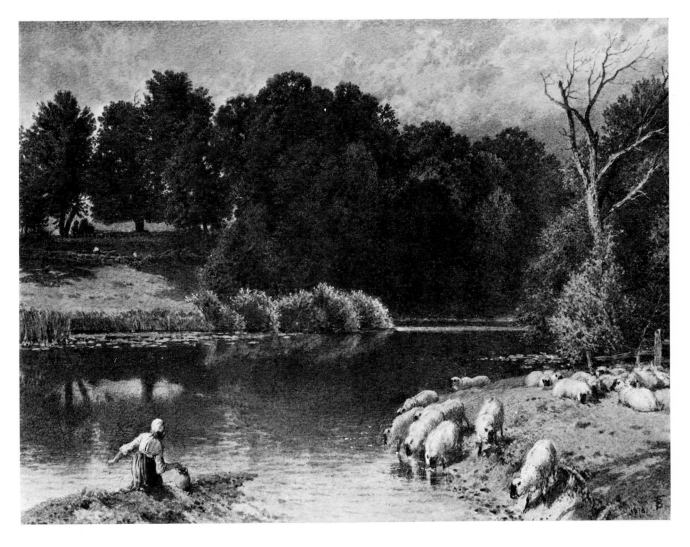

Water-colour RIVER SCENE WITH SHEEP. S & D 1873 9 x 12¾ in.
Courtesy, M. Newman Ltd., London

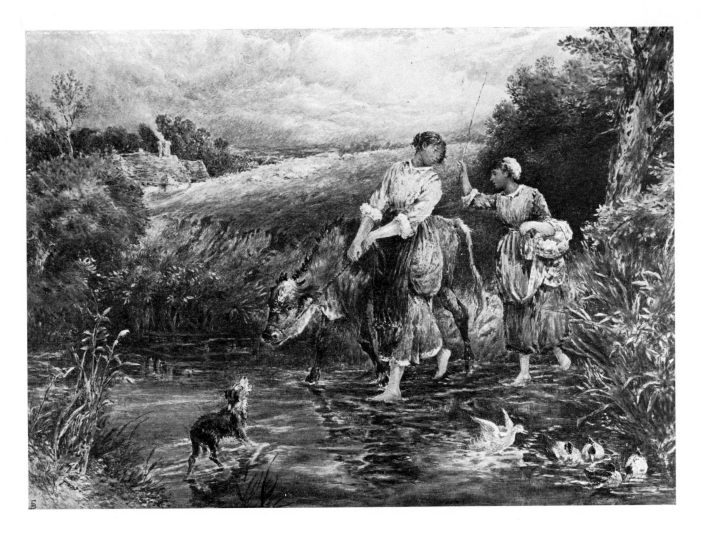

Water-colour **CROSSING THE STREAM** $11\frac{3}{4}$ x 17 in.

Formerly in collection of Mr. & Mrs. M. Hanan, Dunedin

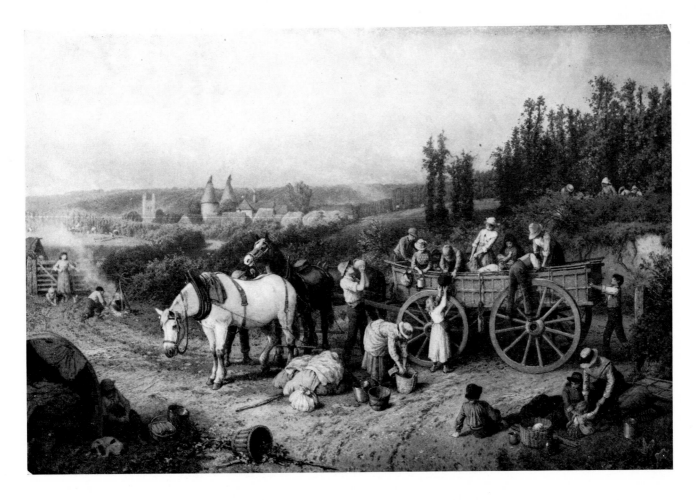

Water-colour THE ARRIVAL OF THE HOP PICKERS, FARNHAM 29 x 42 in.
Courtesy, Frost & Reed Ltd., Bristol and London

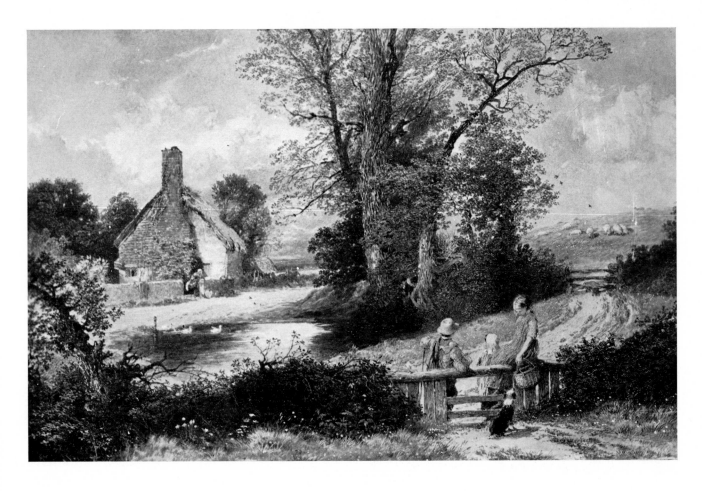

Water-colour AT THE STILE
 Courtesy, The Leger Galleries Ltd., London

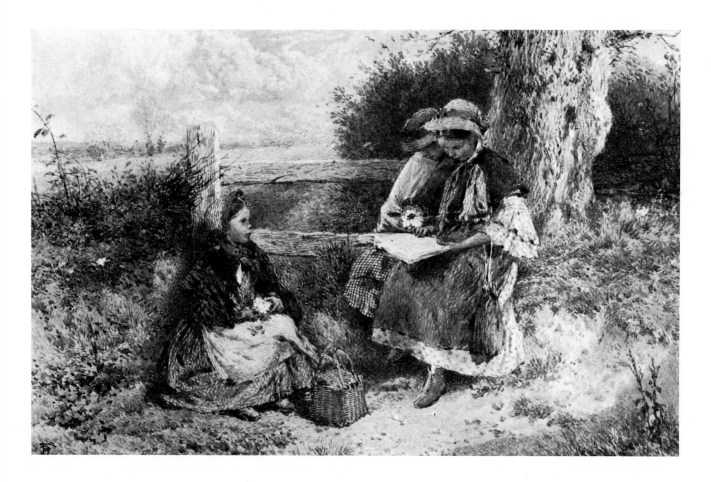

Water-colour

THE PRIMROSE GATHERERS
Courtesy, M. Newman Ltd., London

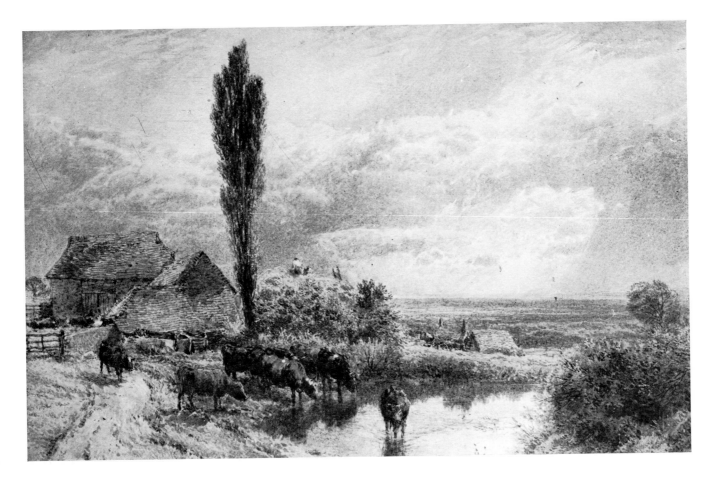

Water-colour **A SURREY HOMESTEAD** $6\frac{3}{4}$ x $10\frac{3}{4}$ in.

Courtesy, M. Newman Ltd., London

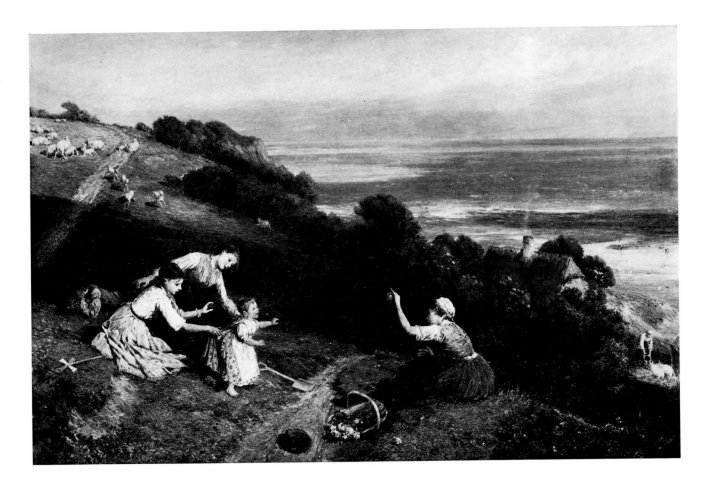

Oil on canvas GIRL WITH AN ORANGE $38\frac{3}{4}$ x $59\frac{1}{4}$ in.
 In the City Art Gallery, Bristol

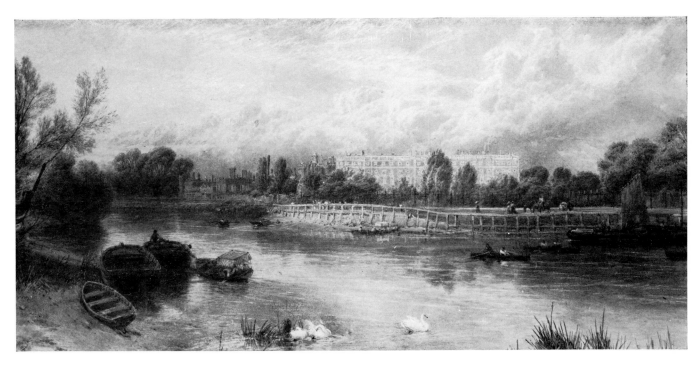

Water-colour HAMPTON COURT FROM THE RIVER $13\frac{1}{2}$ x $27\frac{3}{4}$ in.
Courtesy, Richard Green Fine Paintings, London

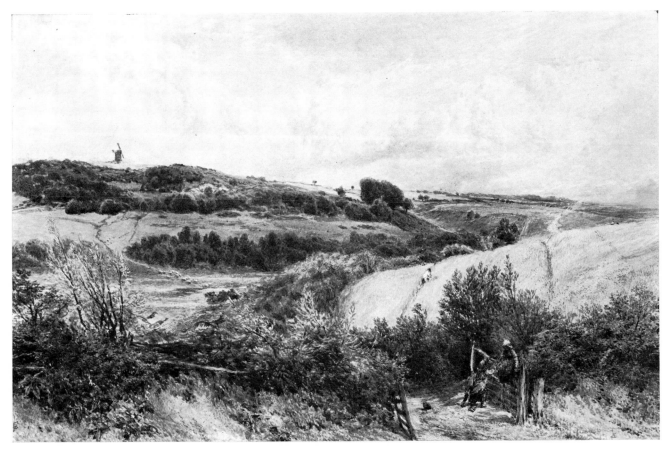

Water-colour VIEW OF HASLEMERE, SURREY $11\frac{1}{2}$ x $17\frac{1}{2}$ in.
Courtesy, Richard Green Fine Paintings, London

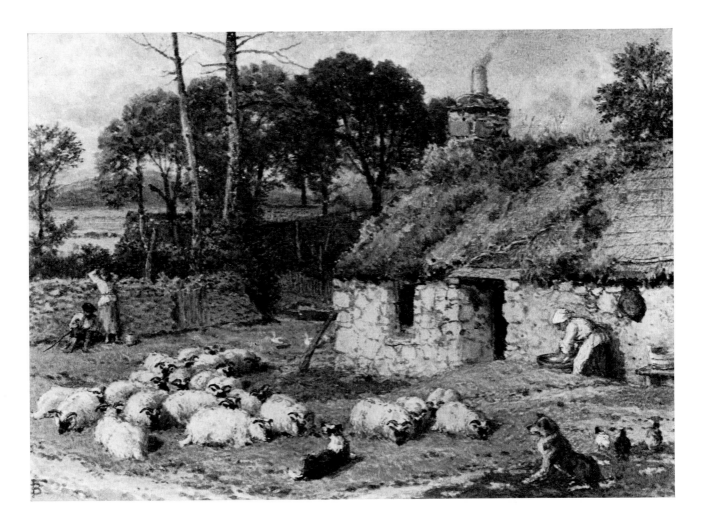

Water-colour HIGHLAND COTTAGE WITH SHEEP
Courtesy, The Leger Galleries Ltd., London

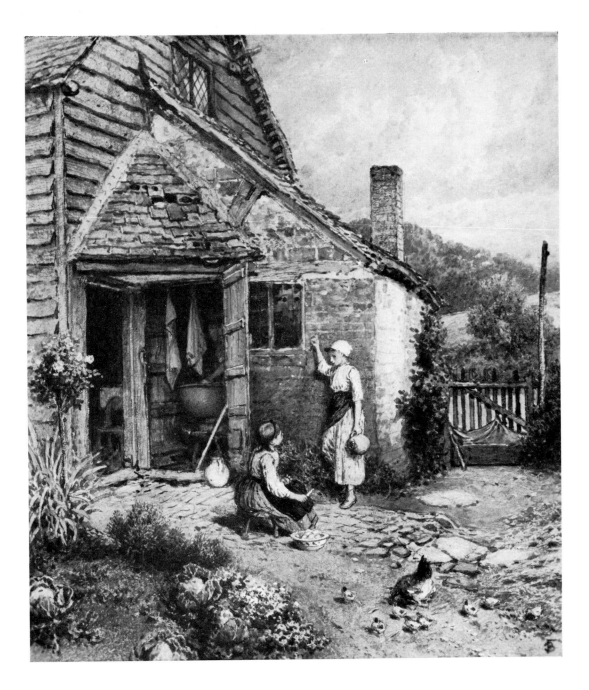

Water-colour THE GOSSIPERS

Courtesy, The Leger Galleries Ltd., London

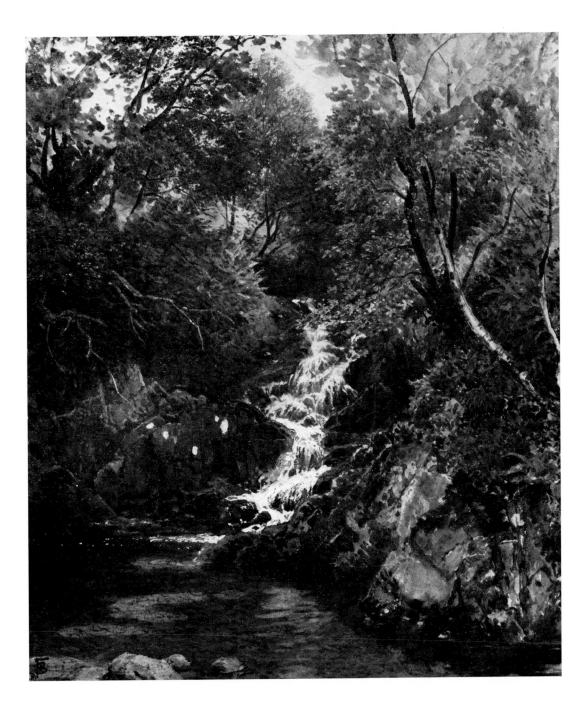

Water-colour WATERFALL, LOCH ACHRAY
Courtesy, Mr. I. R. D. Byfield $12\frac{1}{4}$ x 10 in.

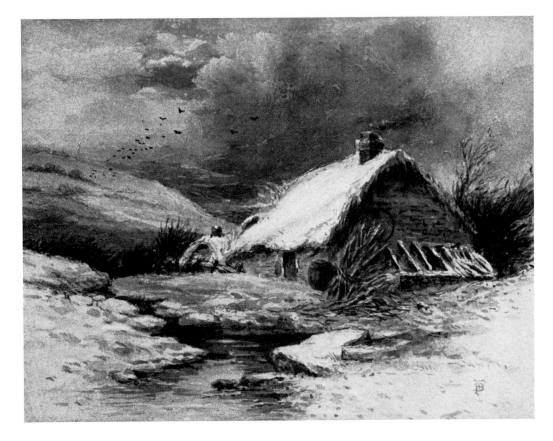

Water-colour **THATCHED COTTAGE IN SNOW** $4\frac{1}{4}$ x 6 in.
Courtesy, Gerald Norman Gallery, London

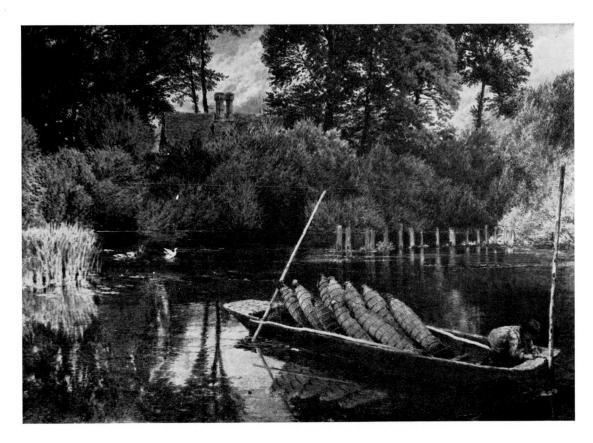

Water-colour **THE YOUNG EEL ANGLER** $11\frac{1}{2}$ x 17 in.
Courtesy, Stanhope Shelton Esq.

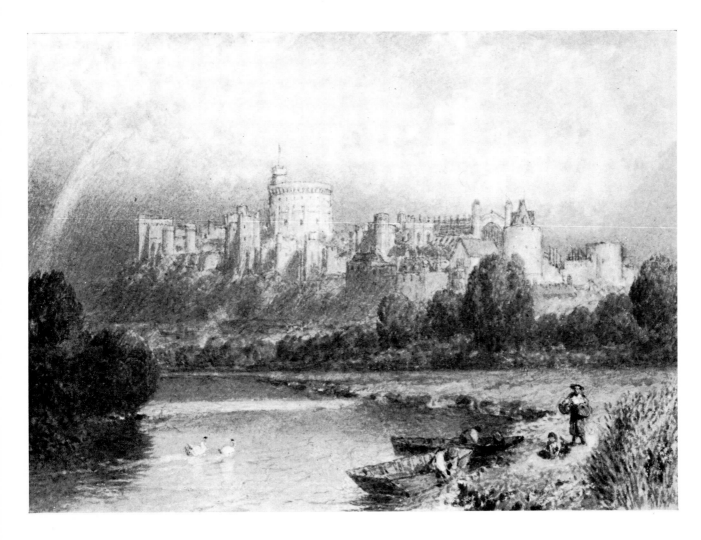

Water-colour **WINDSOR CASTLE** $3\frac{7}{8} \times 5\frac{5}{8}$ in.

Courtesy, Appleby Brothers, London

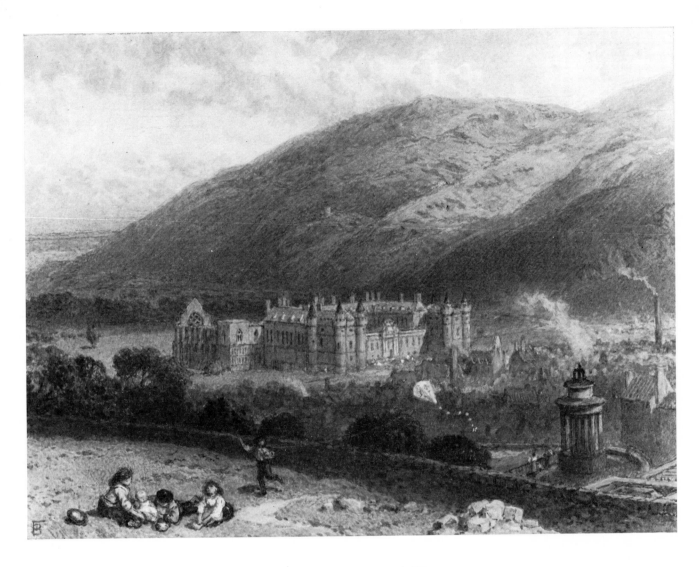

Water-colour

HOLYROOD PALACE
Courtesy, The Leger Galleries Ltd., London

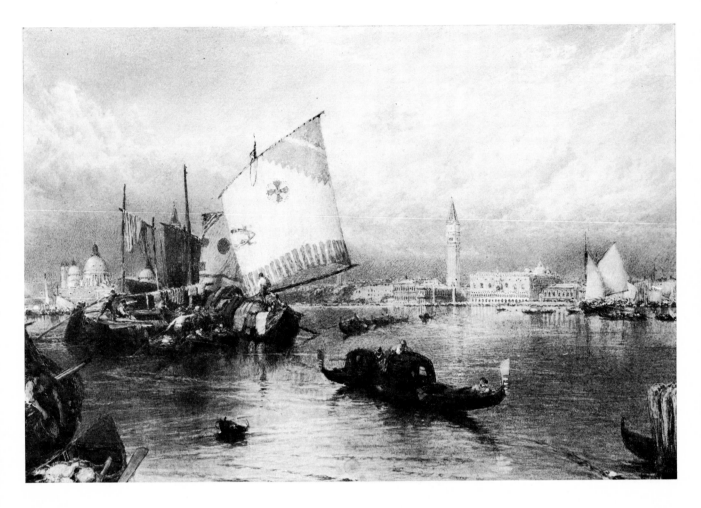

Water-colour THE BALINO, VENICE $11\frac{1}{4}$ x 16 in.
Courtesy, Richard Green Fine Paintings, London

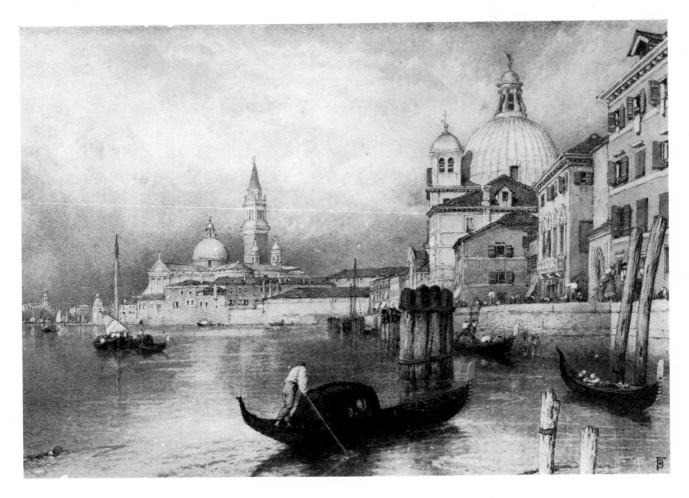

Water-colour THE CHURCHES OF THE PRESENTAZONE $8\frac{1}{4}$ x 12 in.
AND SAN GIORGIO MAGGIORE, VENICE, FROM THE GIUDECCA
Courtesy, Frost & Reed Ltd., Bristol and London

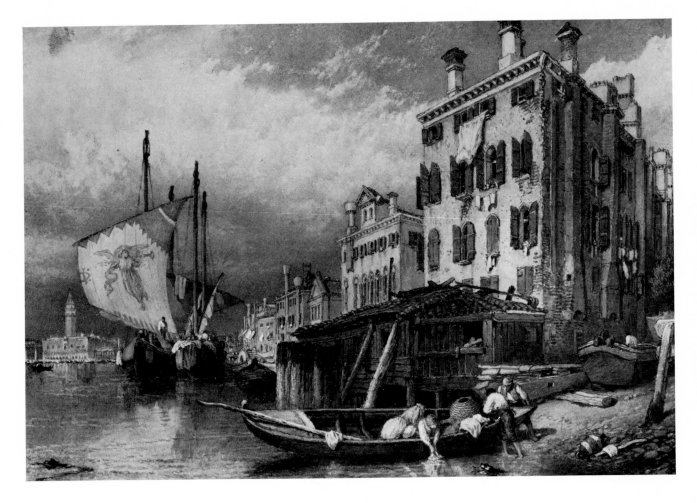

Water-colour VENICE $8\frac{1}{4}$ x $11\frac{3}{4}$ in.
 Courtesy, The Leger Galleries Ltd., London

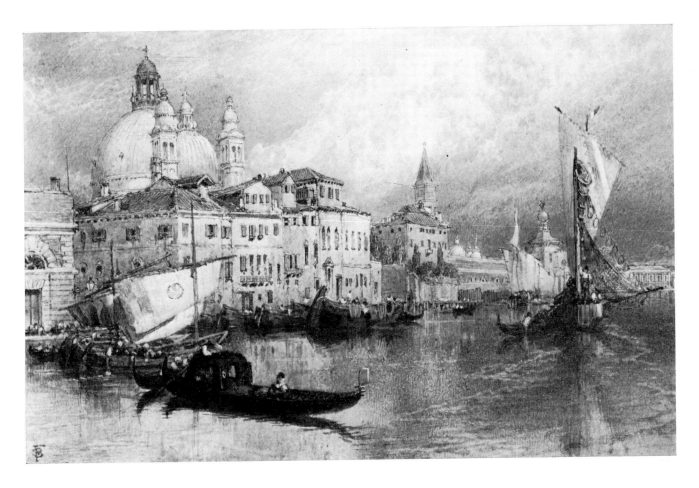

Water-colour SANTA MARIA DELLA SALUTE FROM THE GUIDECCA 6 x 8$\frac{7}{8}$ in.

Courtesy, The Leger Galleries Ltd., London

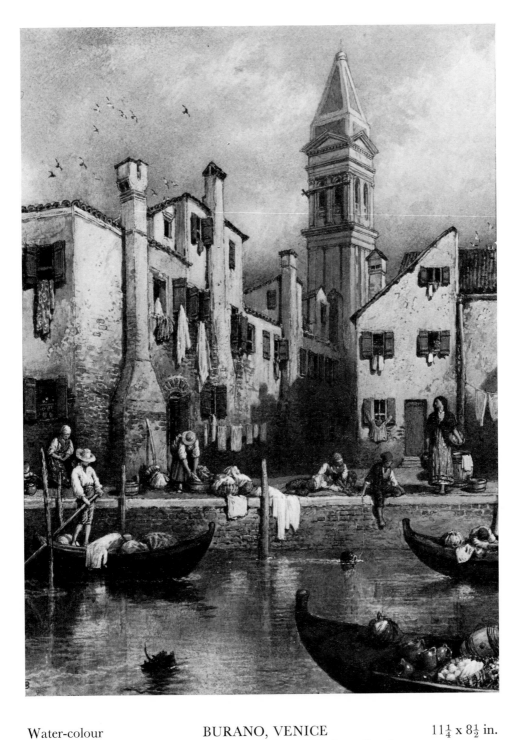

Water-colour BURANO, VENICE $11\frac{1}{4}$ x $8\frac{1}{2}$ in.
Courtesy, Richard Green Fine Paintings, London

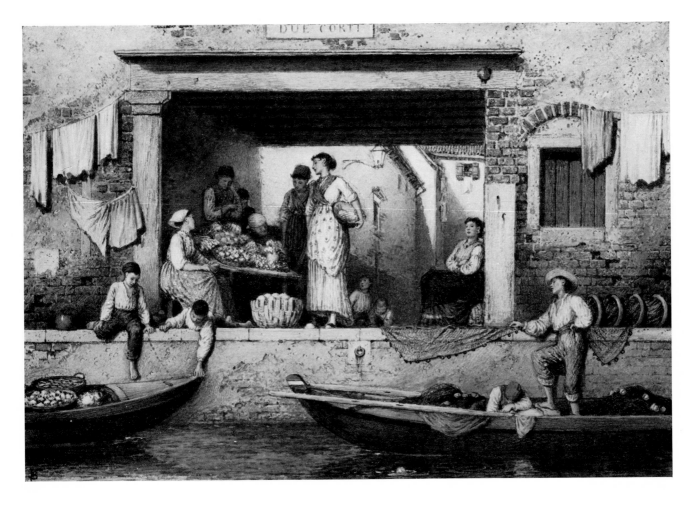

Water-colour THE CALLE PRIMA DUE CORTI, VENICE $8\frac{1}{4}$ x $11\frac{3}{4}$ in.
Courtesy, The Leger Galleries Ltd., London

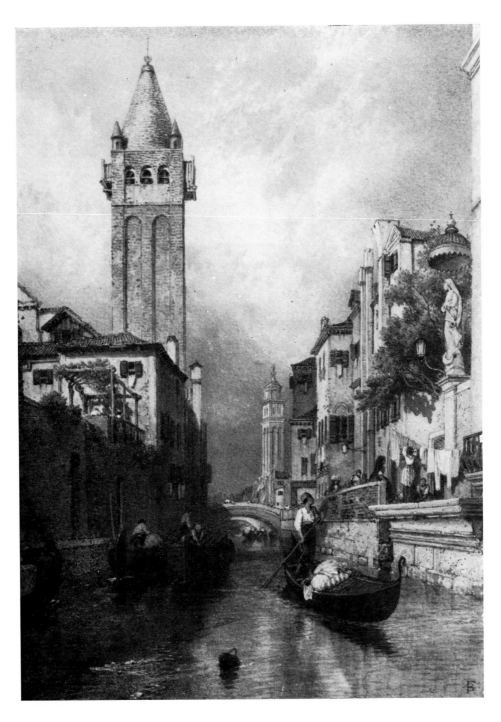

Water-colour THE CHURCH OF ST. BARNABAS APOSTOLO, VENICE $11\frac{1}{2}$ x $8\frac{1}{2}$ in.

Courtesy, Frost & Reed Ltd., Bristol and London

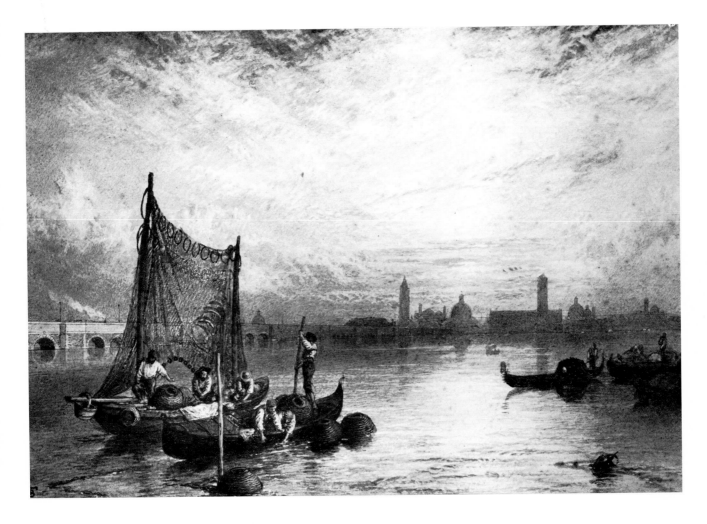

Water-colour THE APPROACH TO VENICE BY RAILWAY 8 x 12 in.

Courtesy, Williams & Son, London

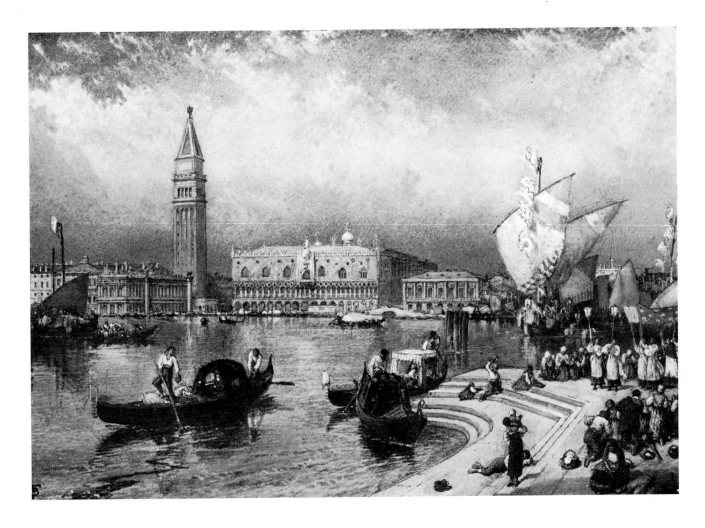

Water-colour THE DOGE'S PALACE FROM SAN GIORGIO MAGGIORE $8\frac{1}{4}$ x 12 in.
Courtesy, Williams & Son, London

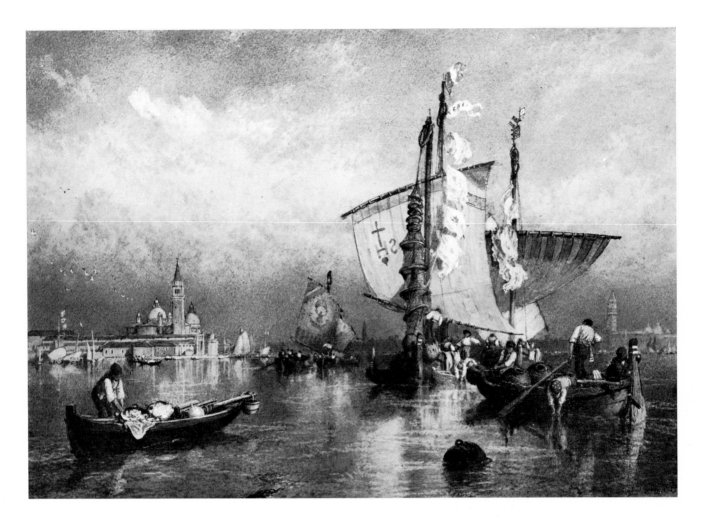

Water-colour FISHING BOATS OFF THE ISLAND OF SAN GIORGIO MAGGIORE 8¼ x 12 in.
Courtesy, Williams & Son, London

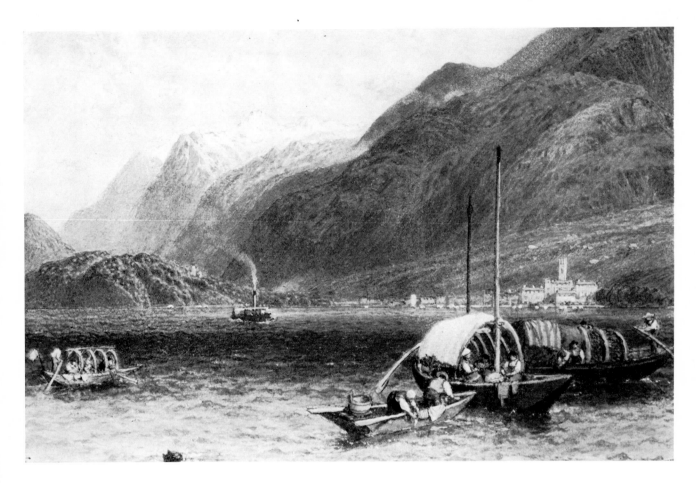

Water-colour A VIEW ON LAKE COMO $4\frac{3}{4}$ x $7\frac{1}{4}$ in.

Courtesy, M. Newman Ltd., London